I

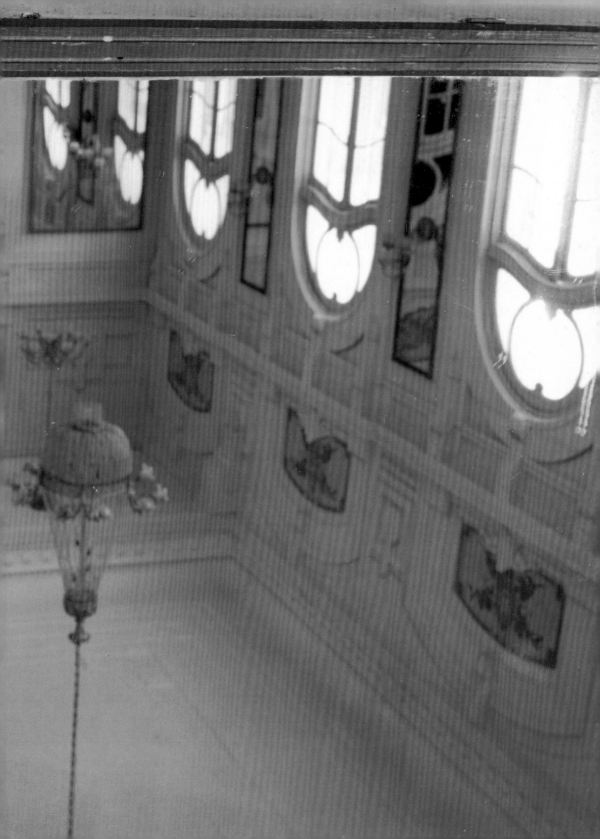

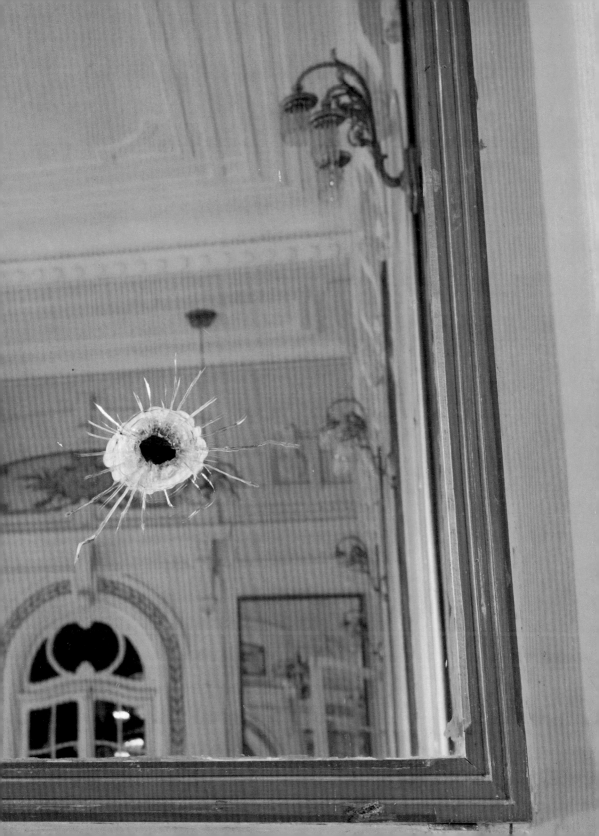

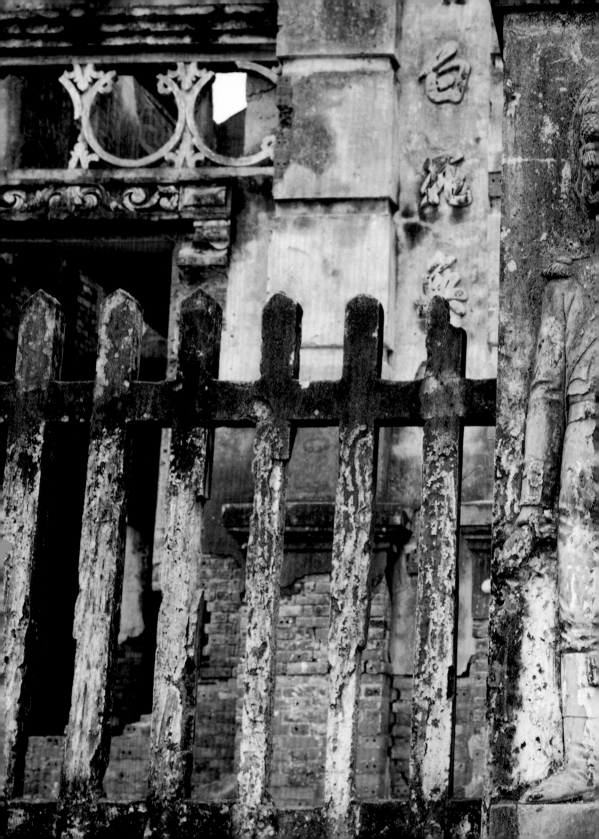

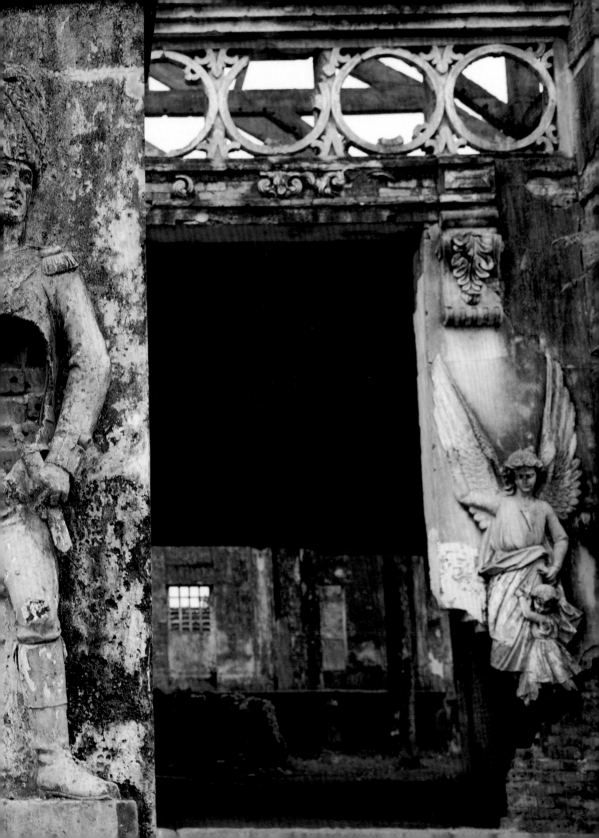

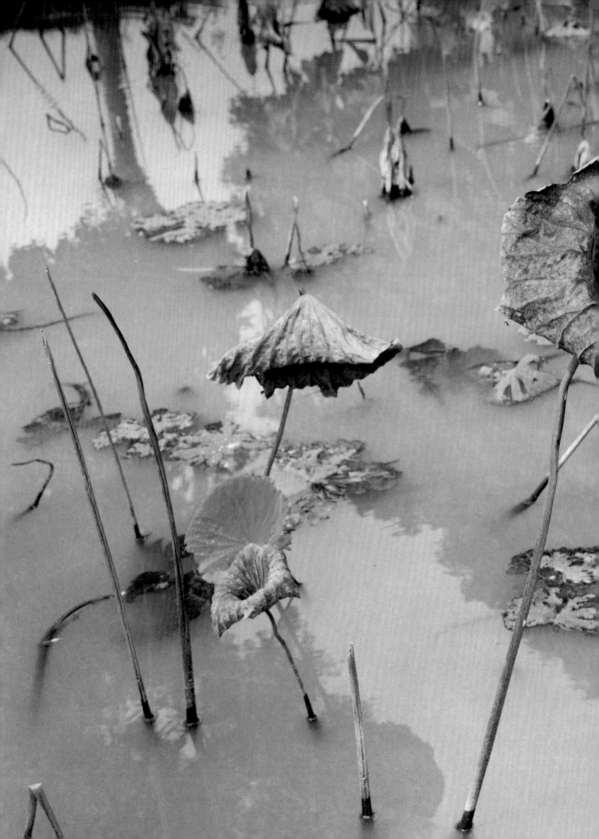

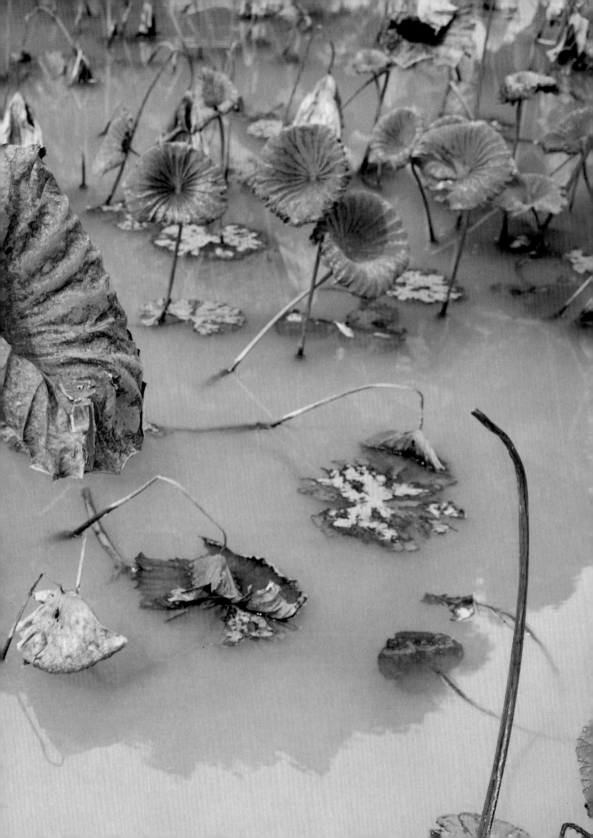

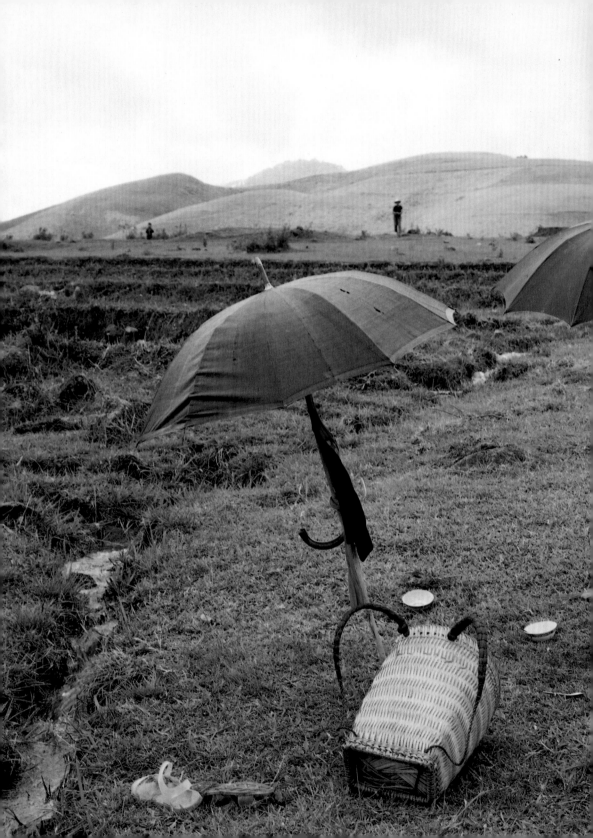

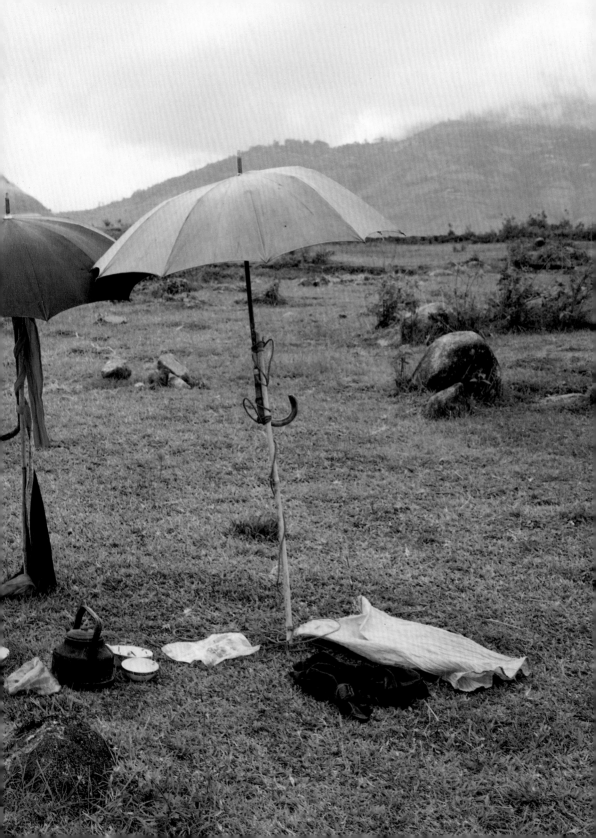

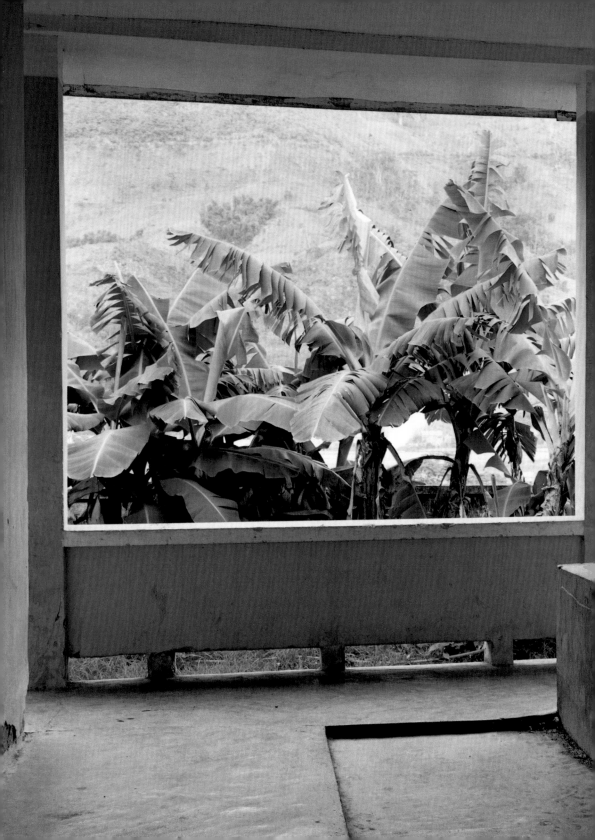

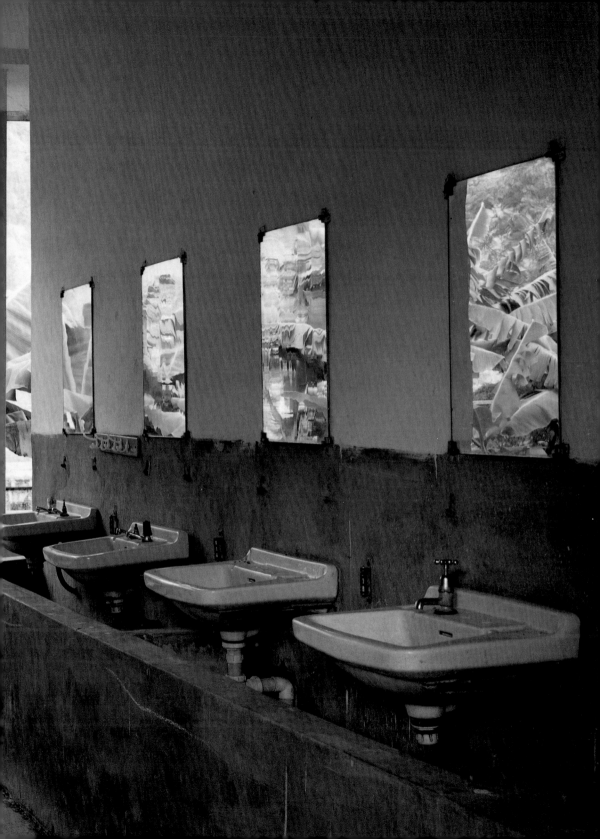

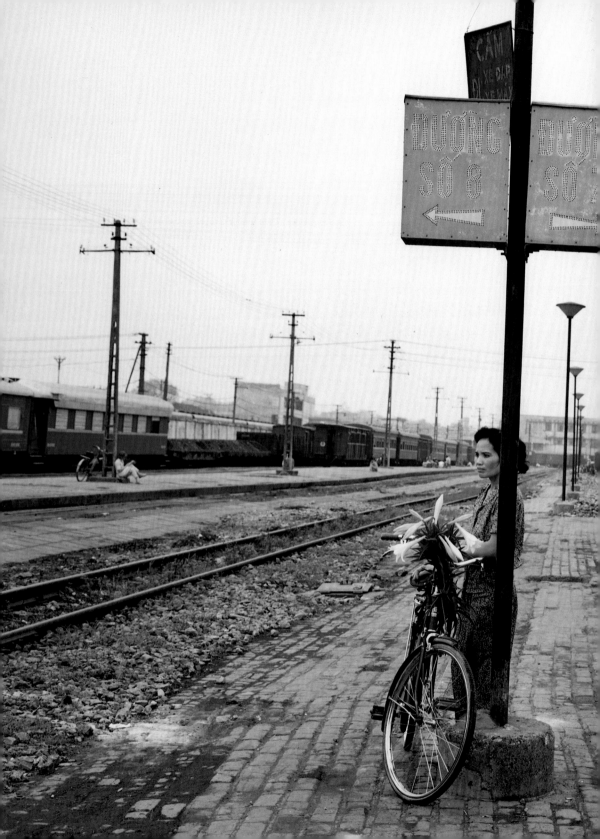

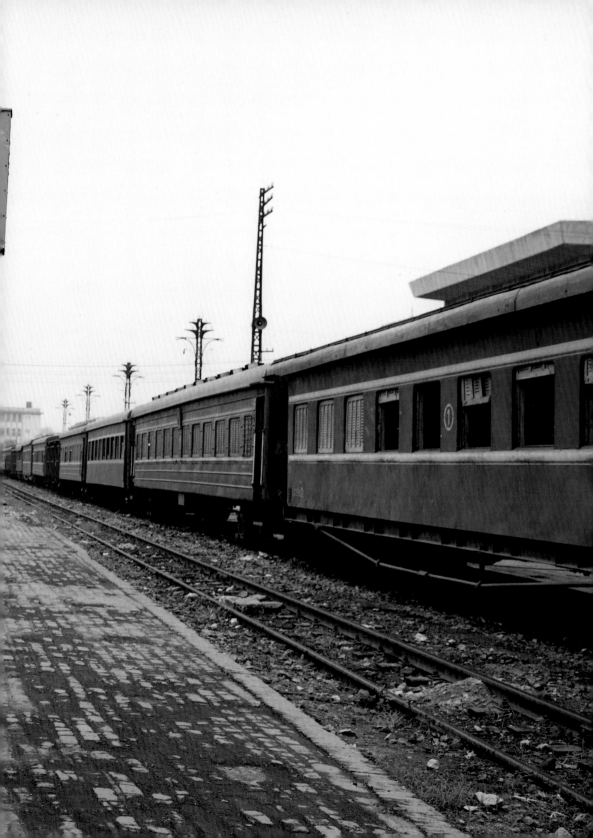

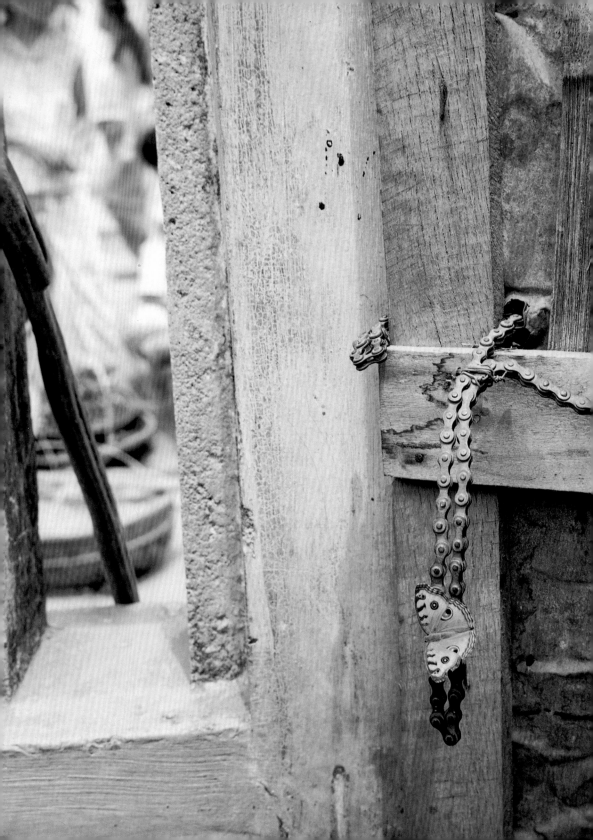

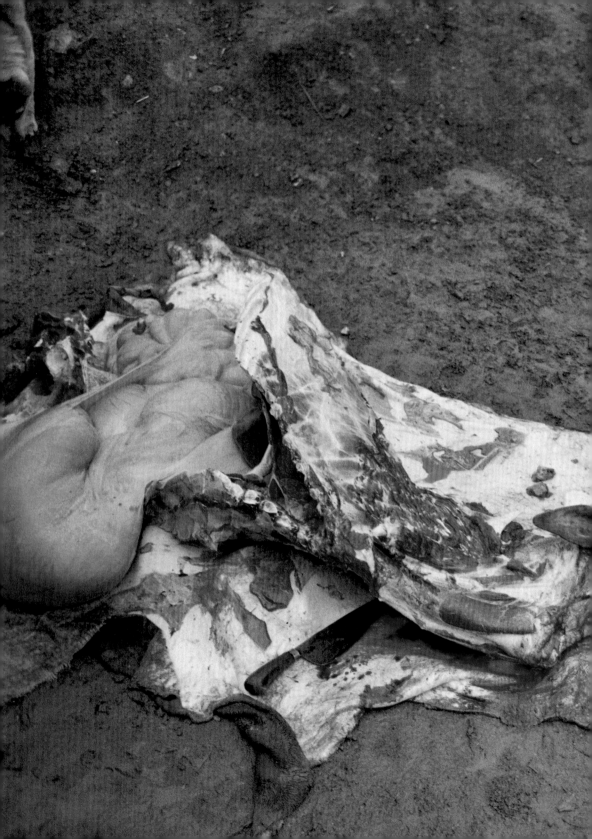

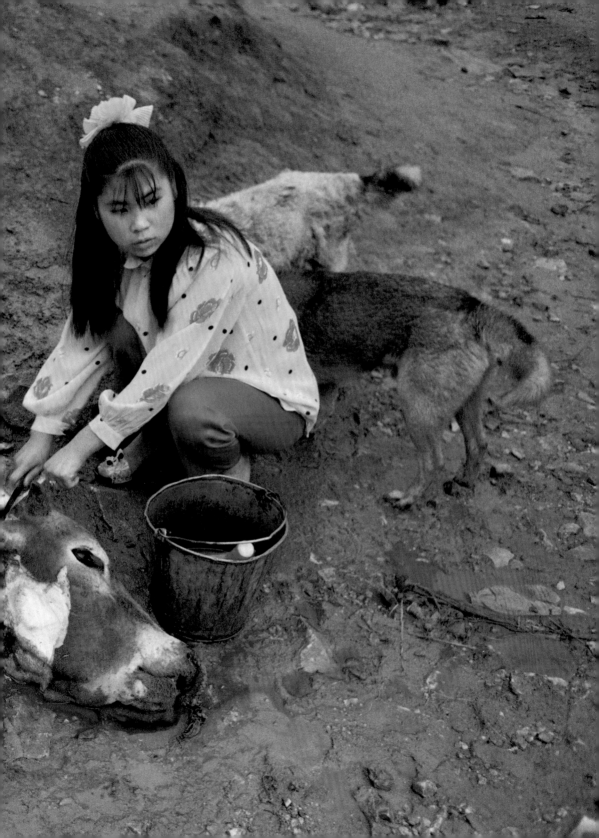

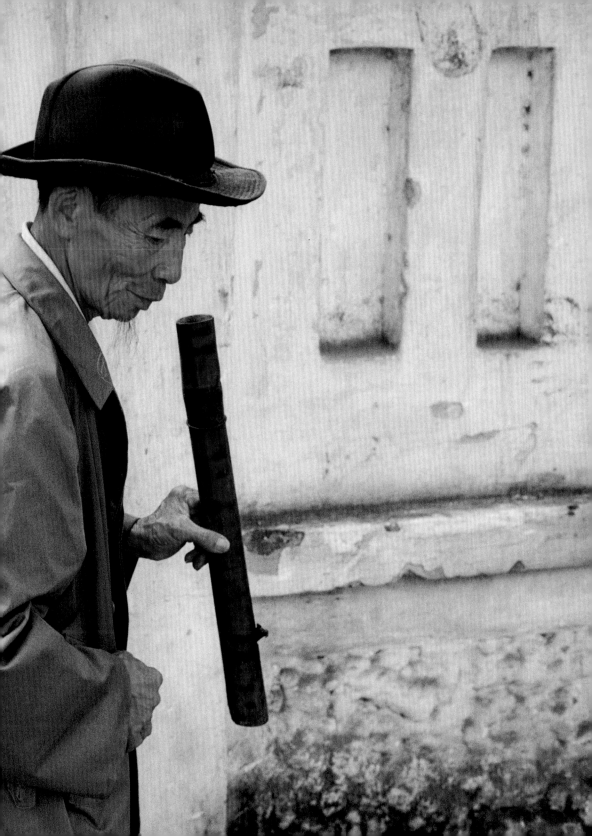

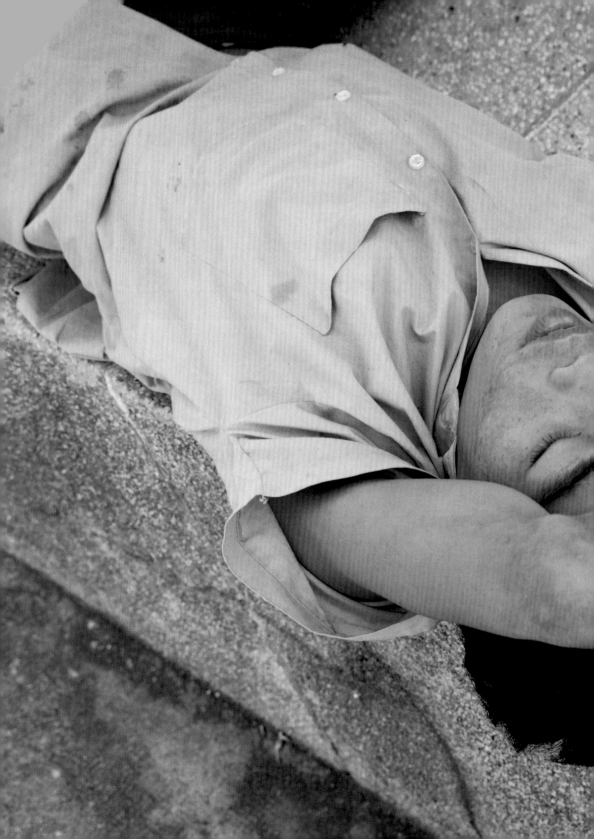

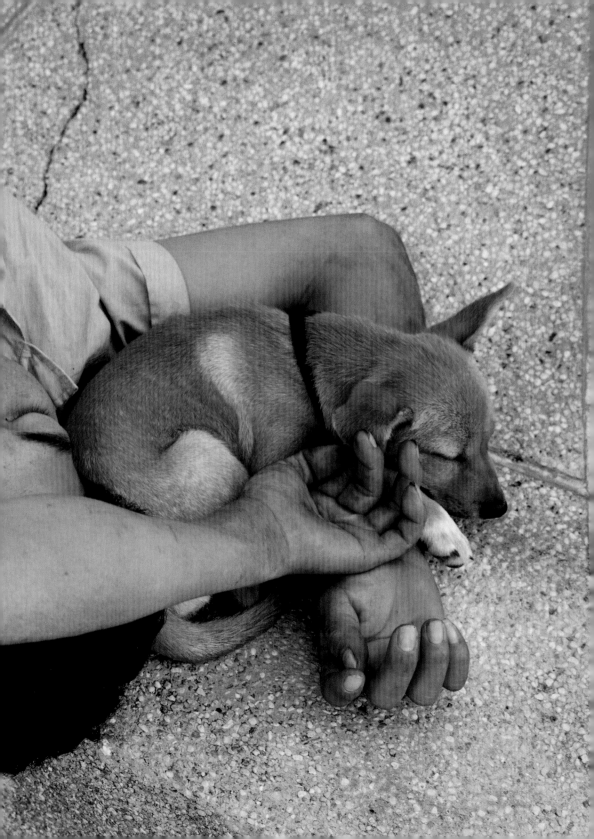

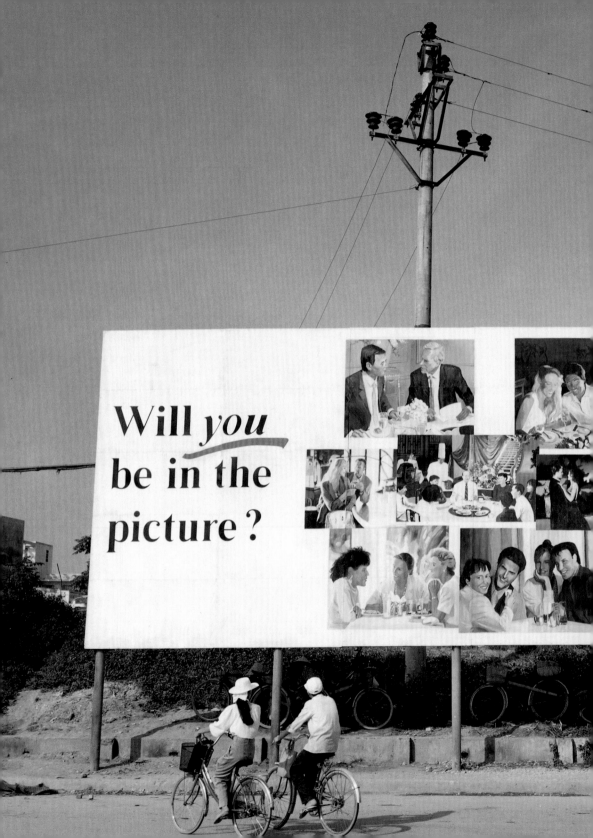

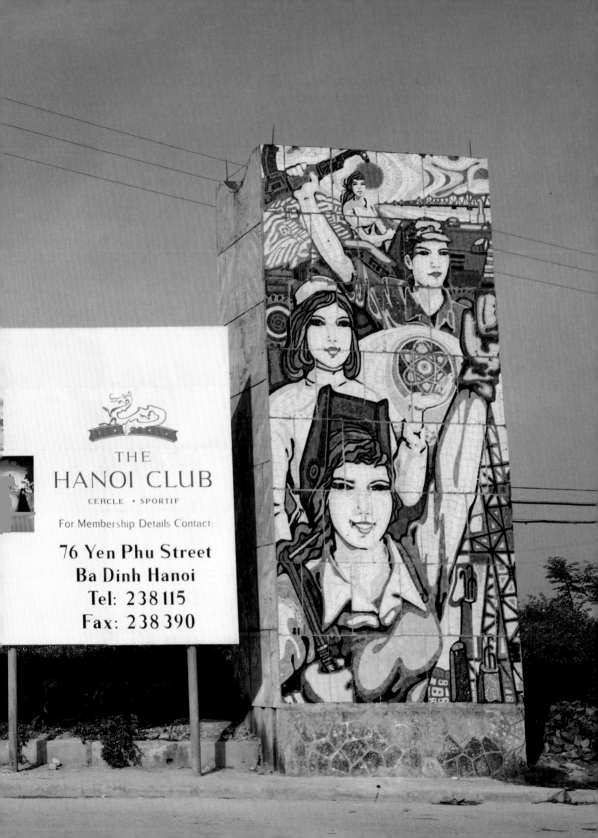

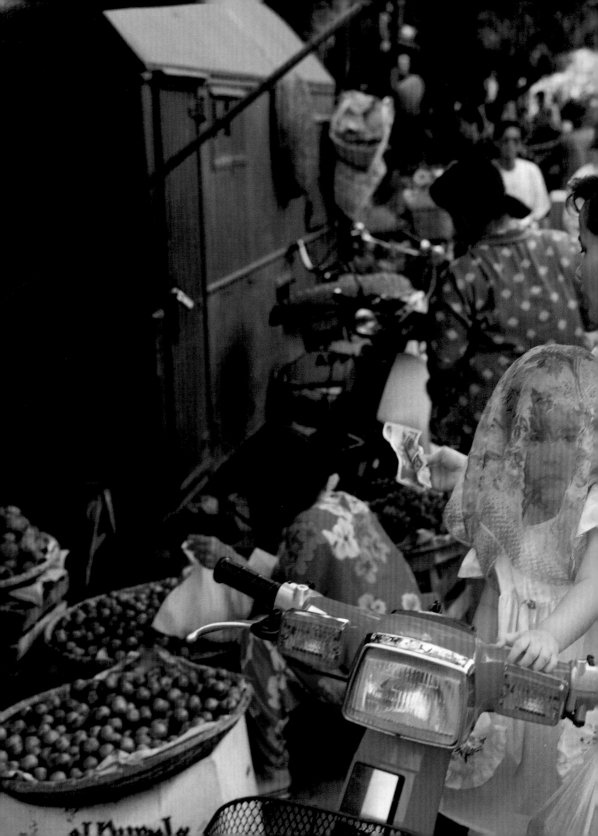

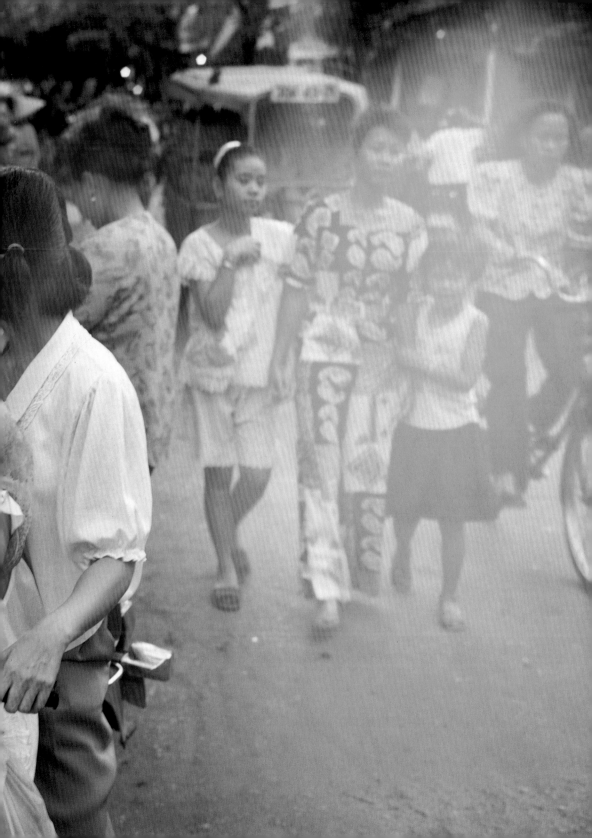

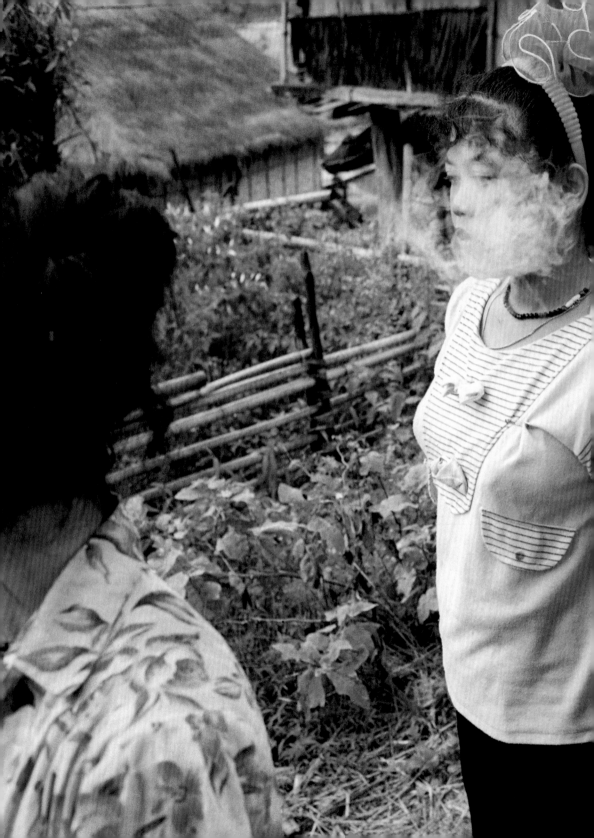

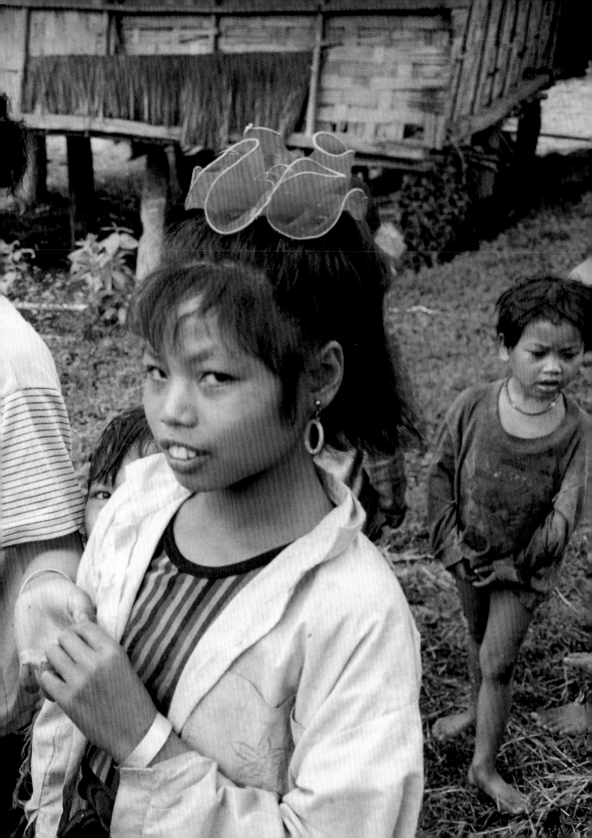

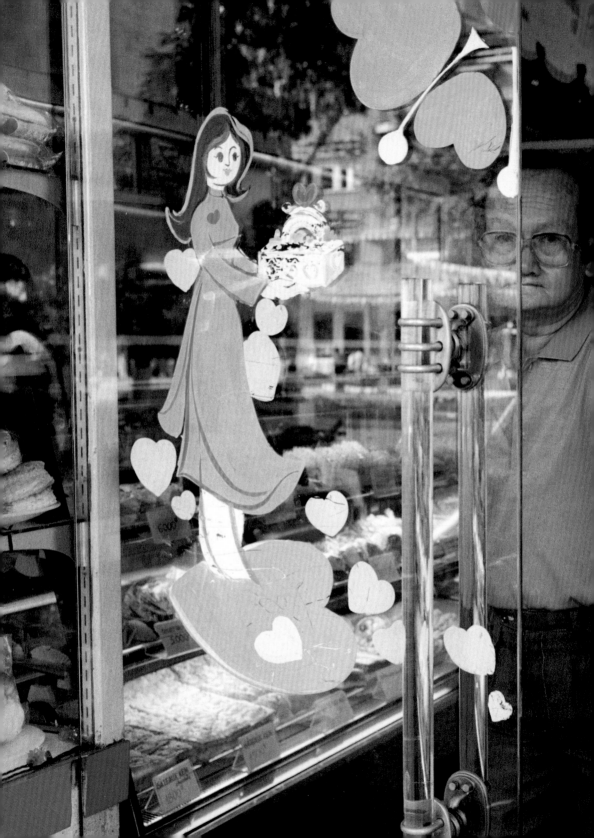

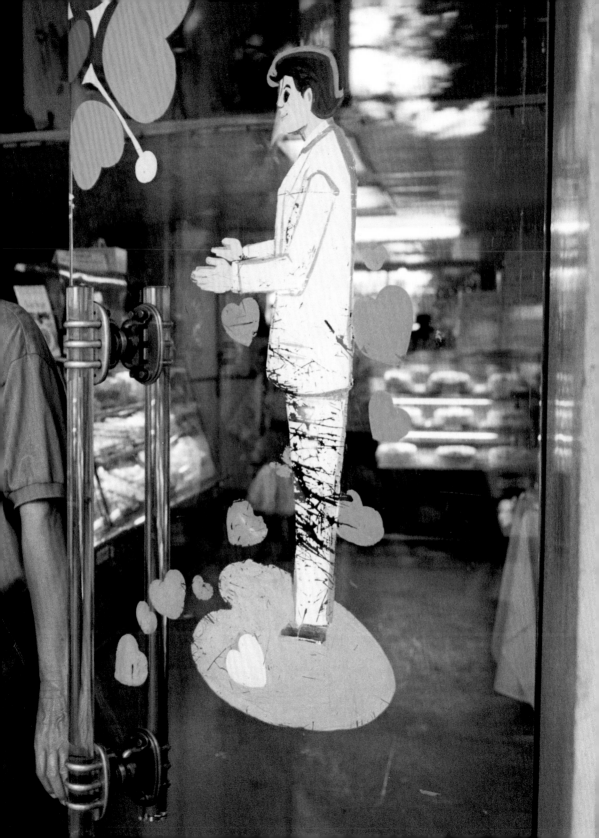

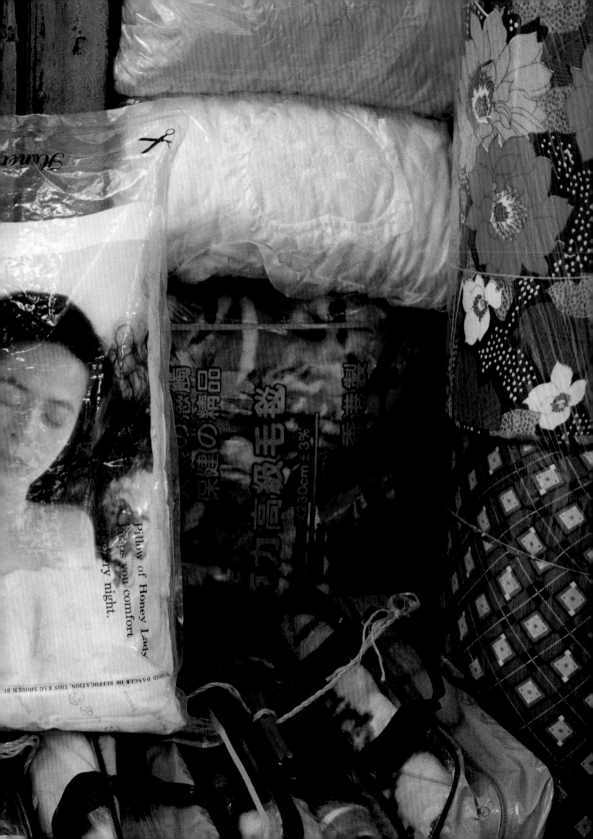

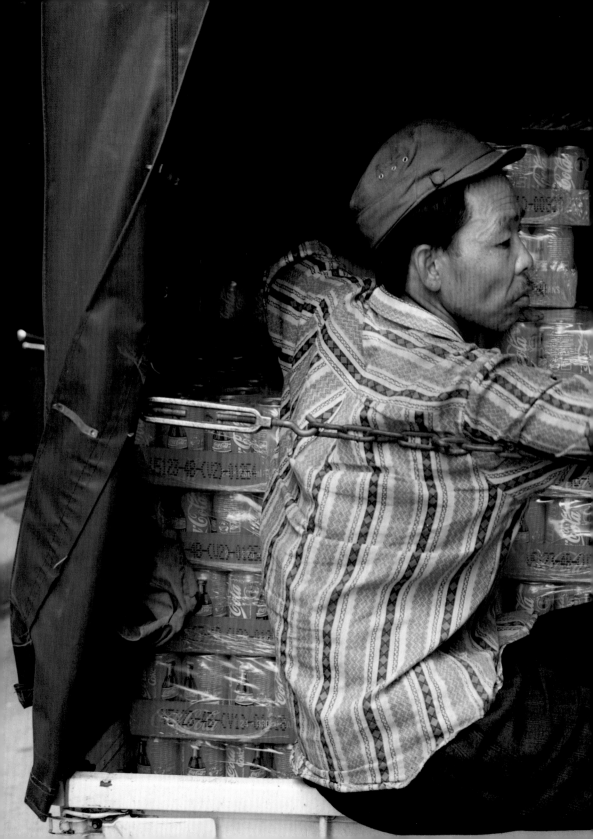

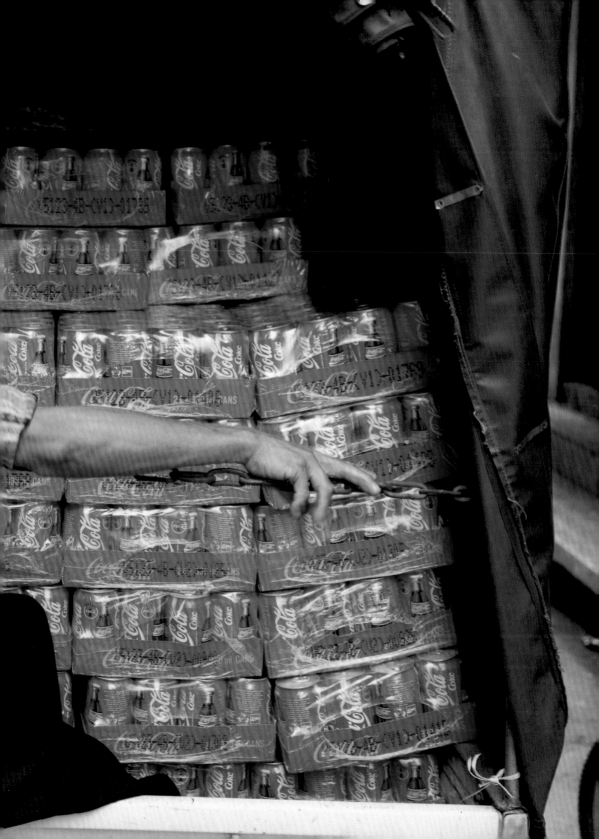

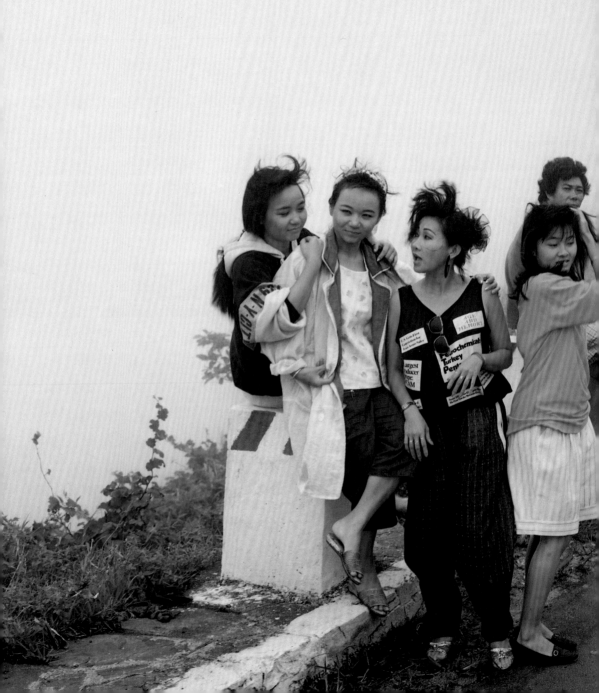

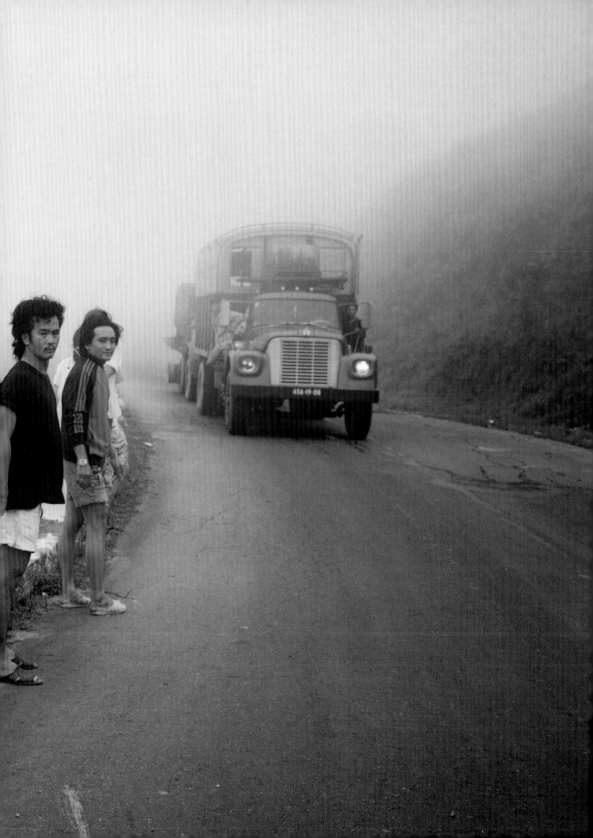

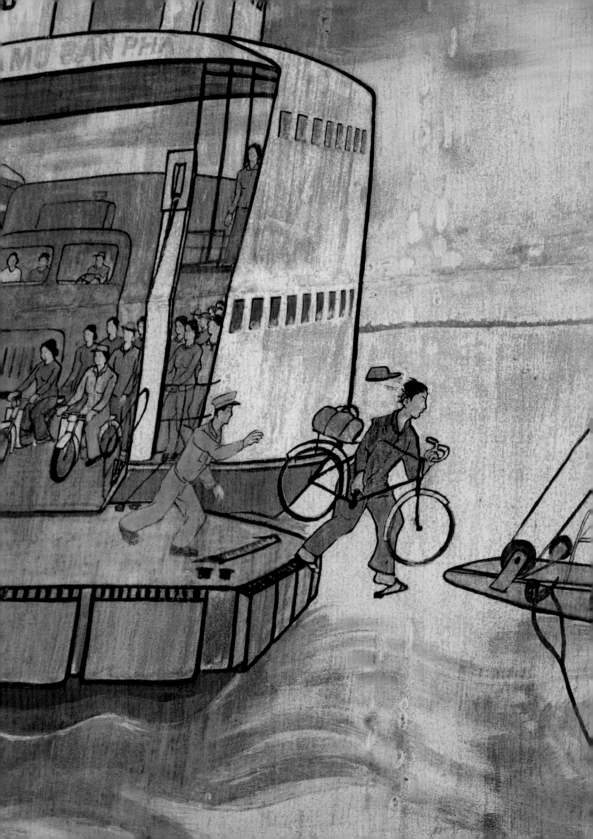

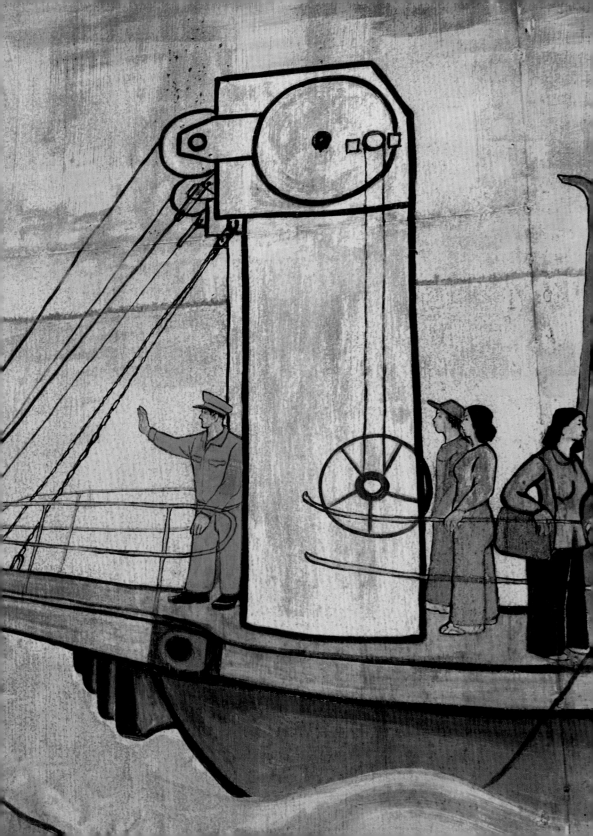

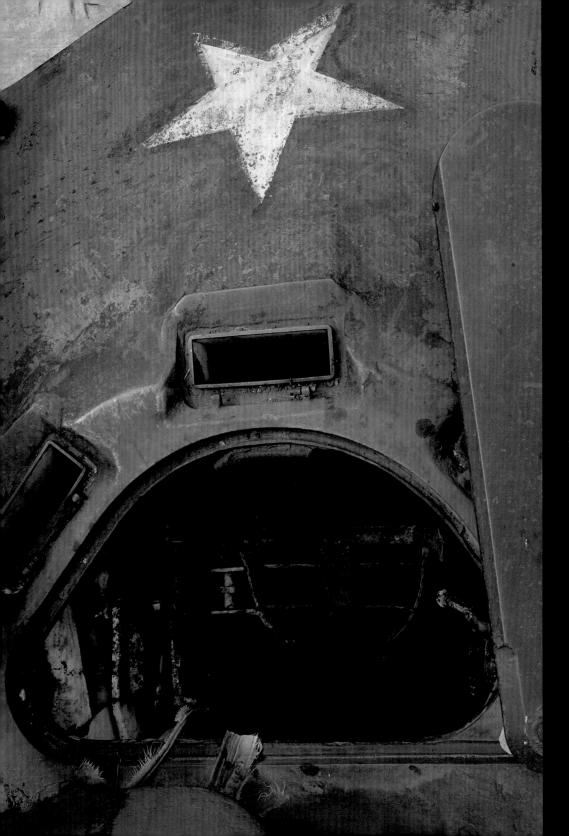

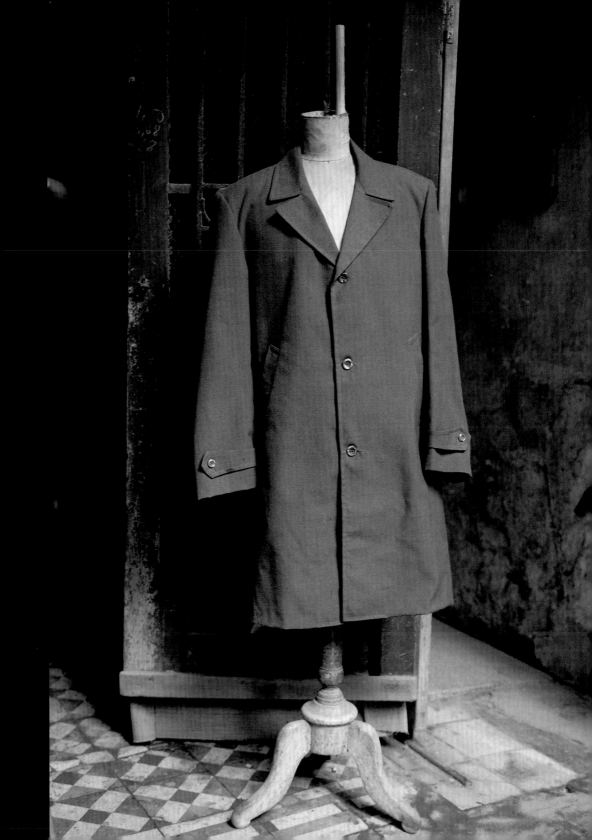

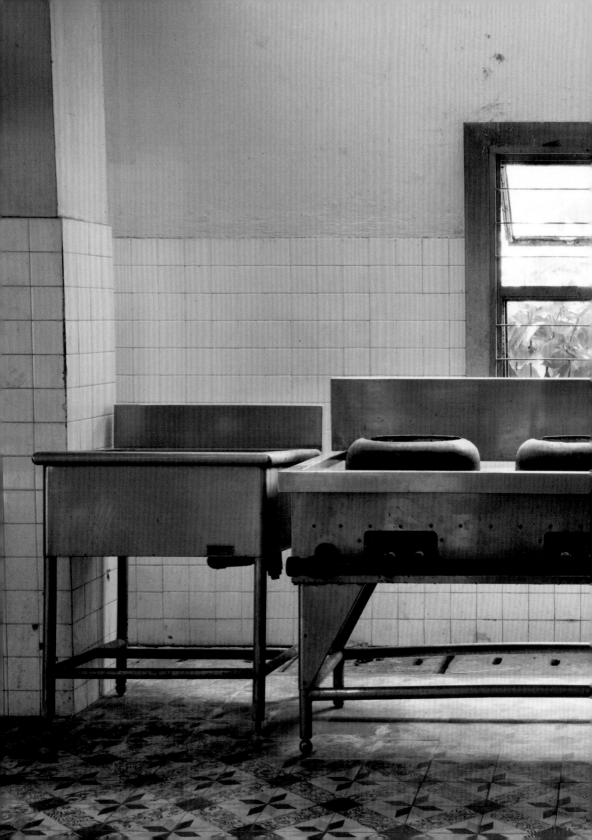

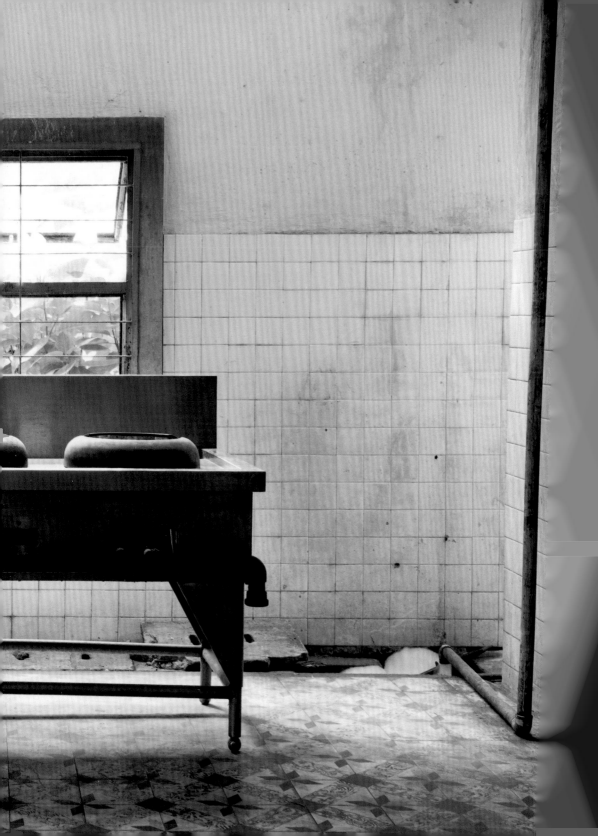

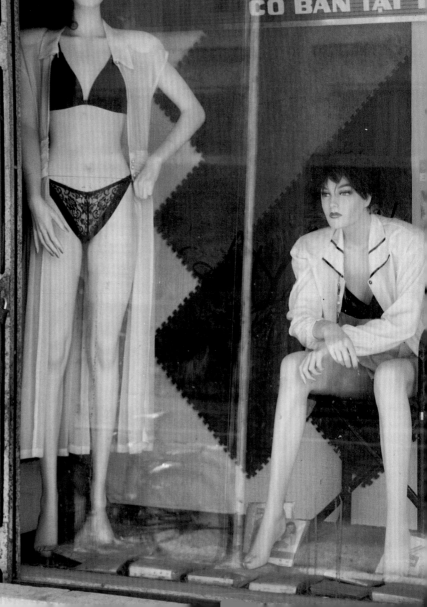

Triumph
INTERNATIONAL

CAO CẤP

NG HAI

Triumph
INTERNATIONAL

TY TRANG PH

G ĐẦU THẾ

phẩm có bán t

Wear at the fashin

SẢN PHẨM N

MELAMINE

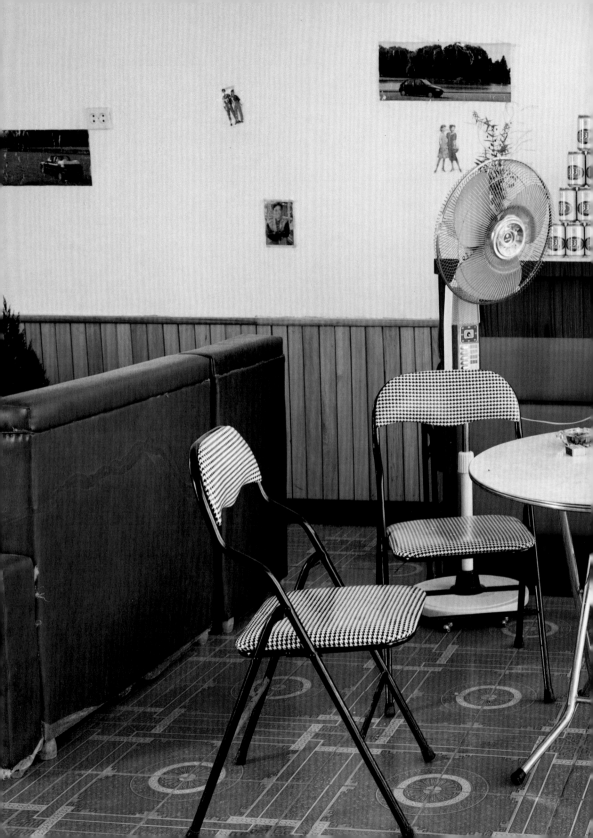

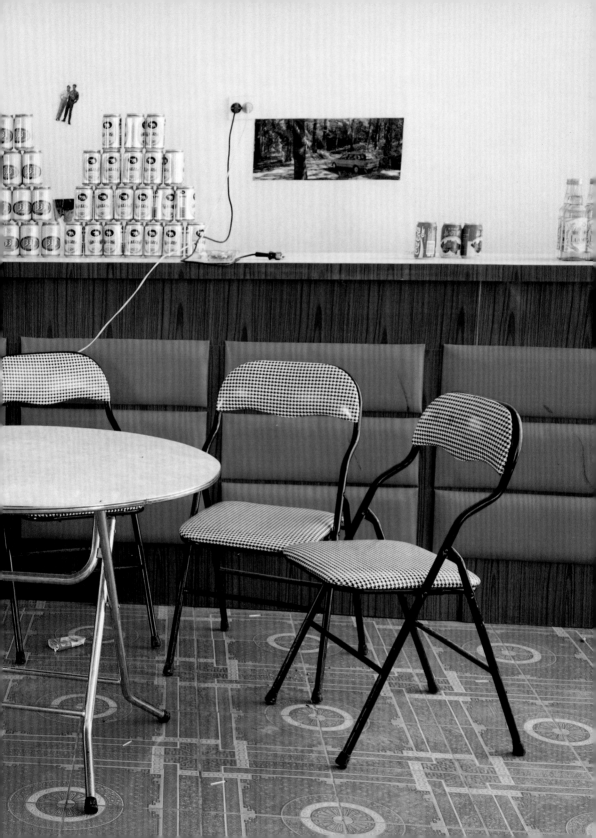

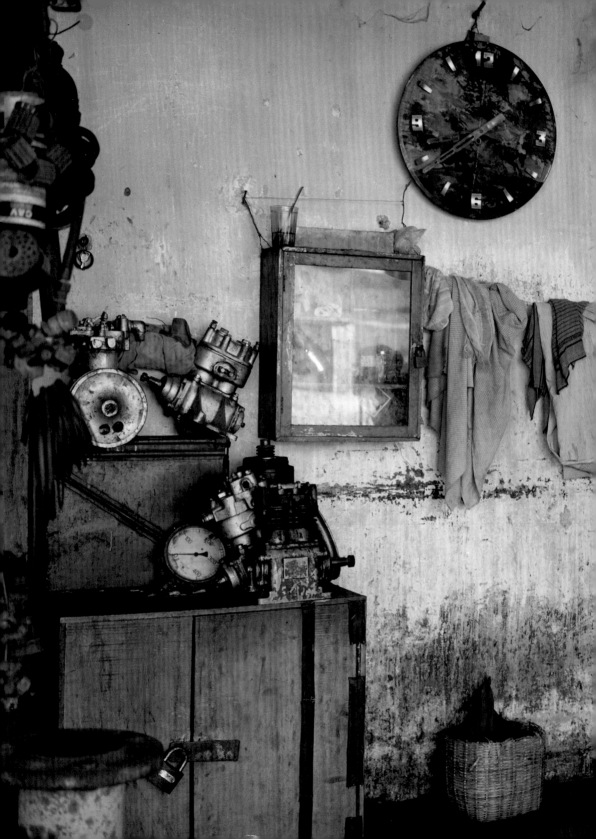

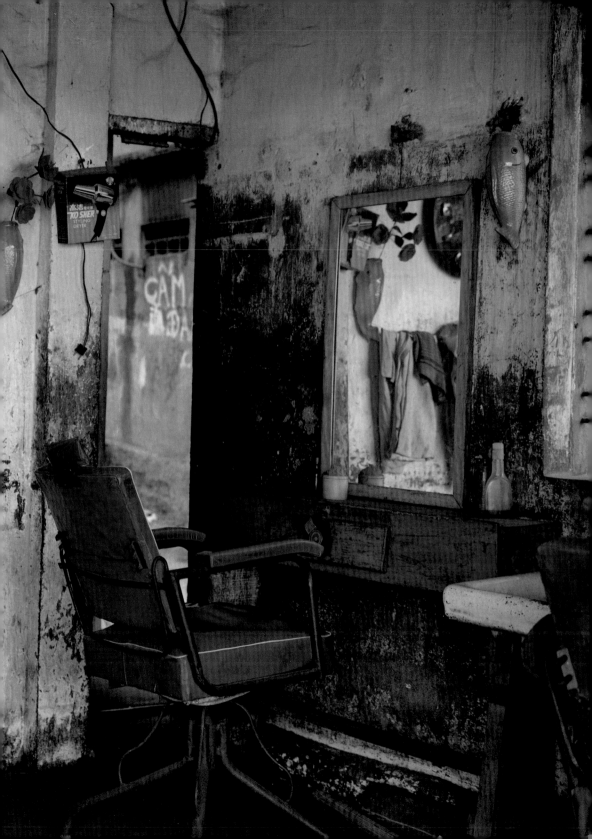

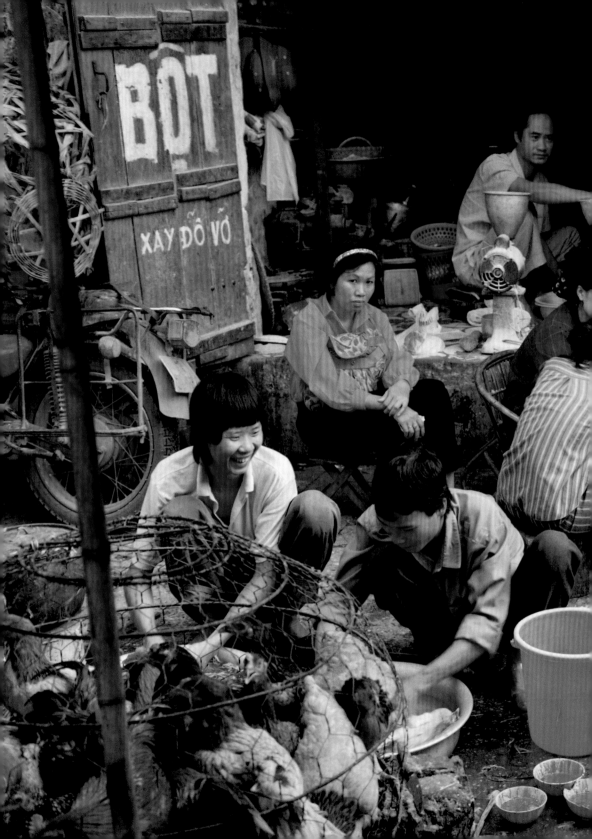

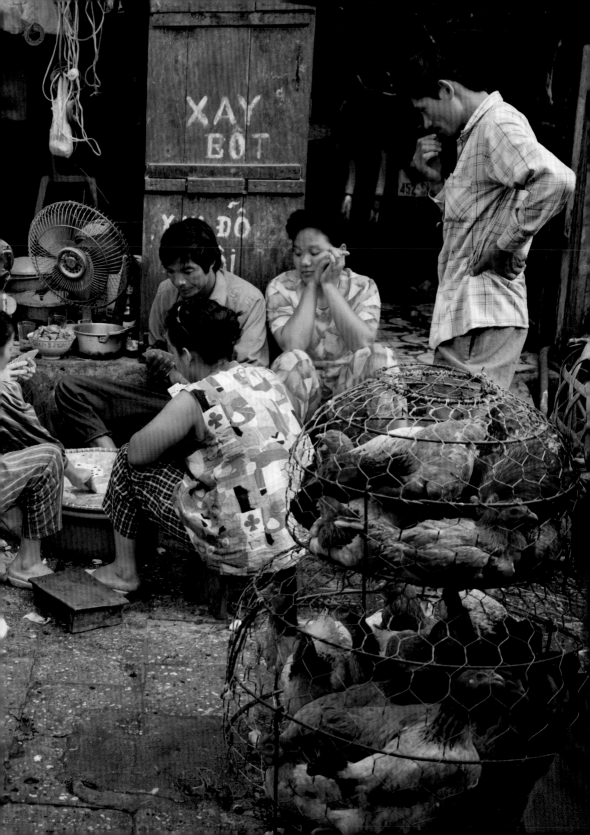

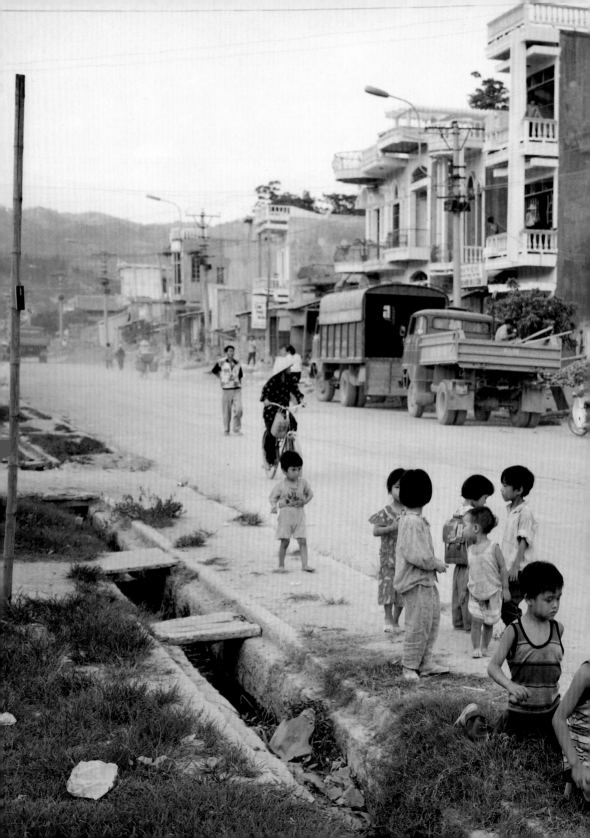

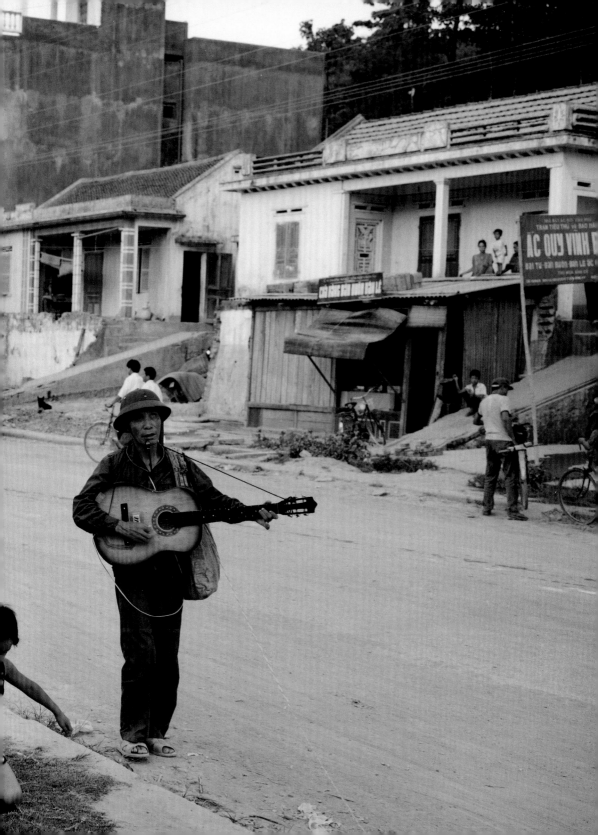

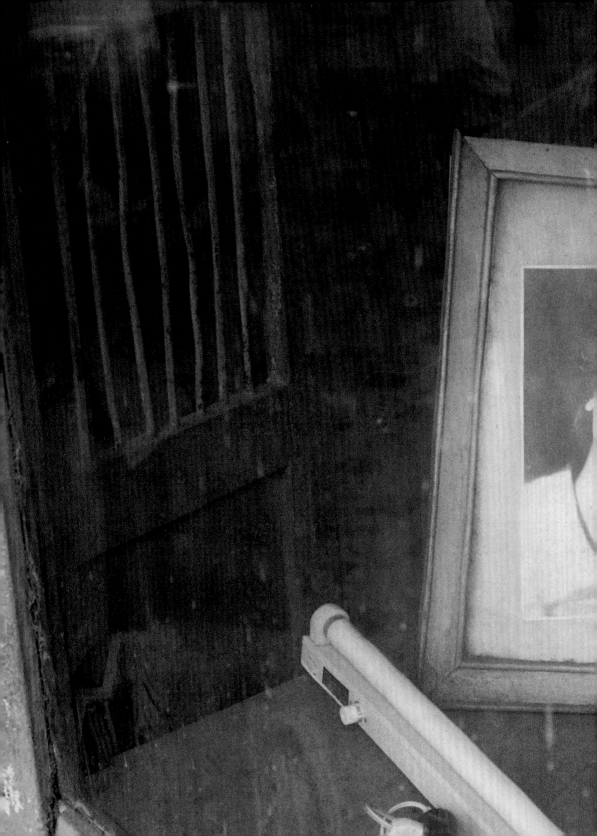

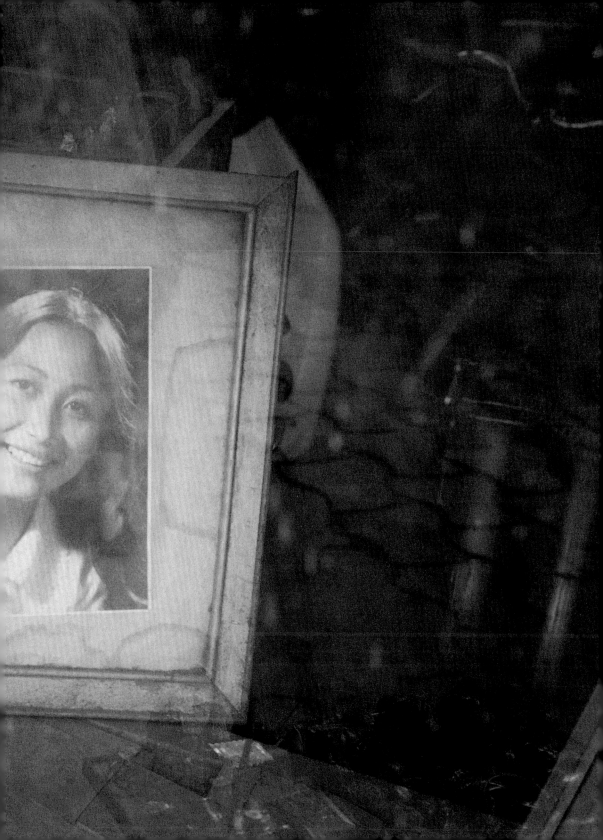

II

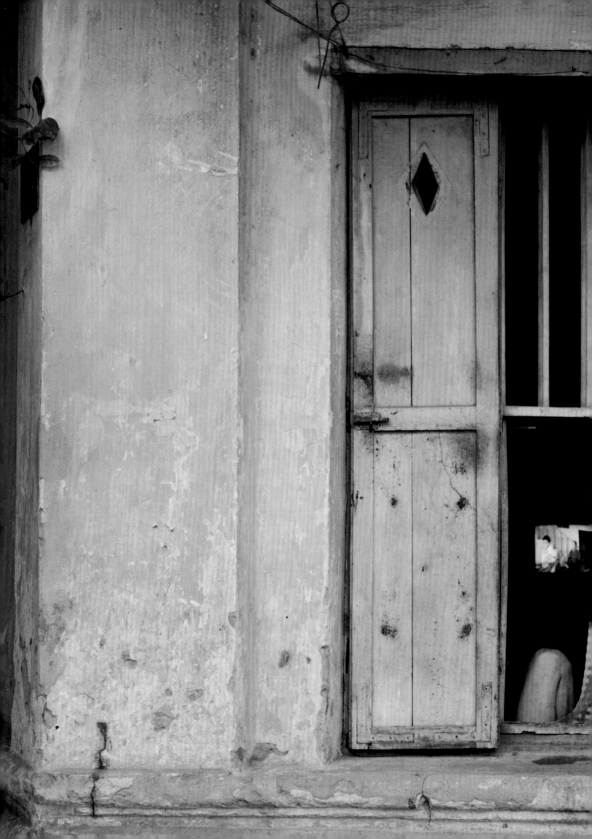

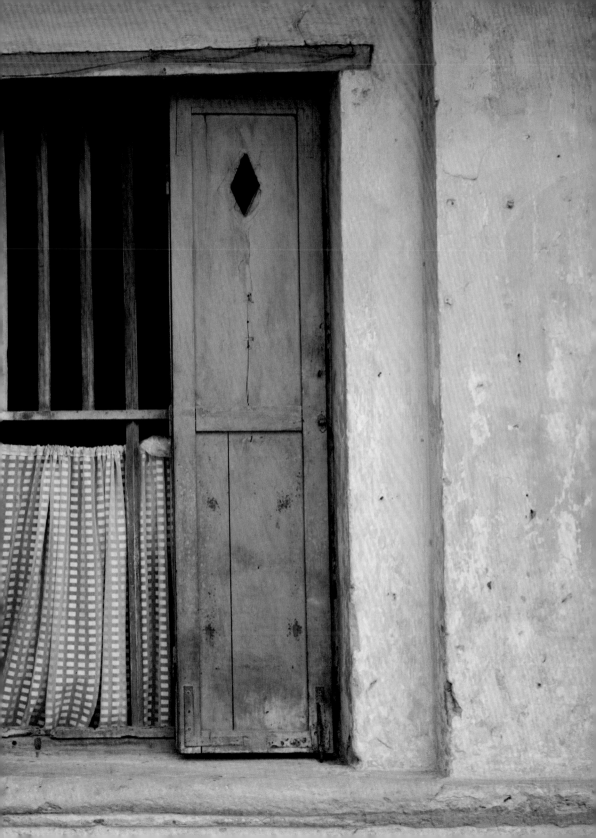

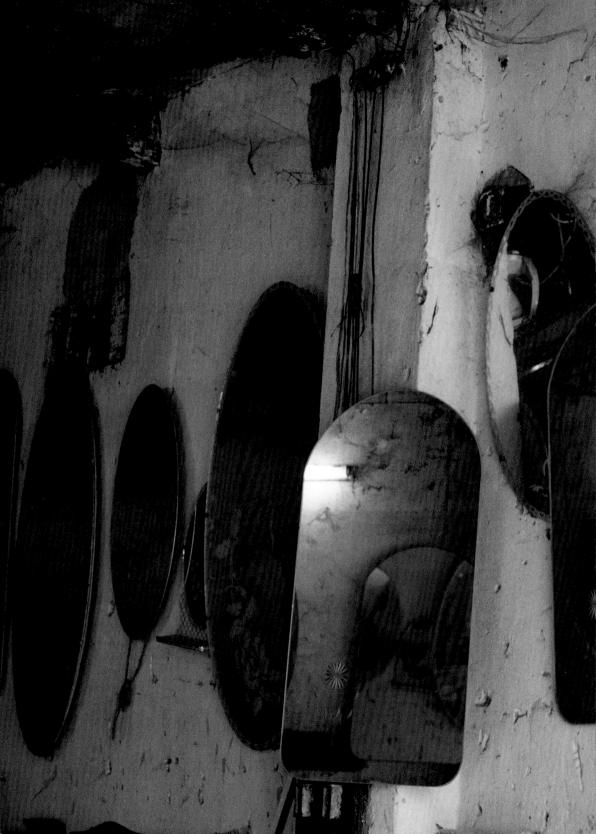

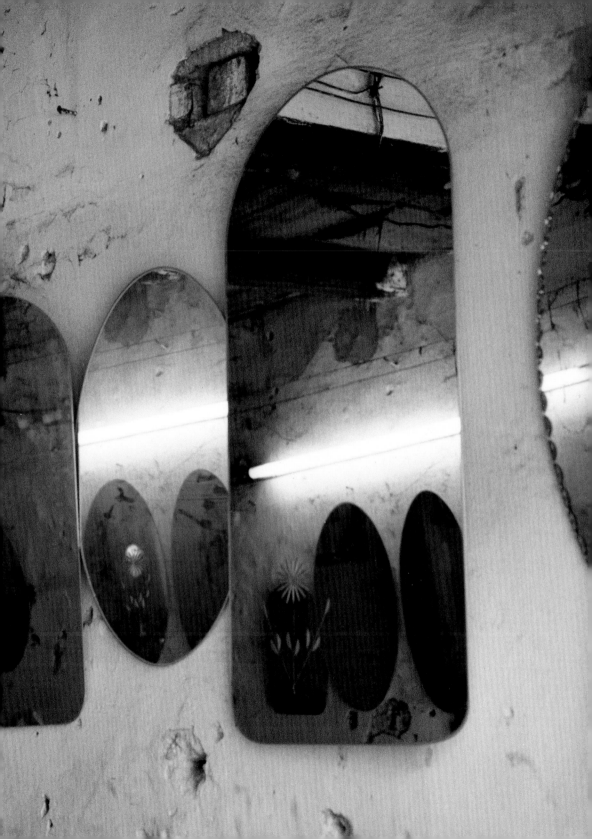

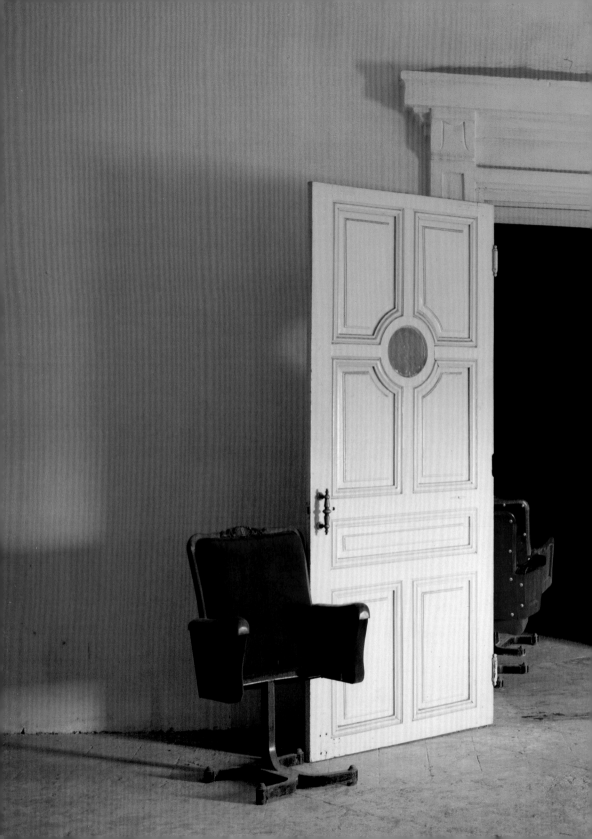

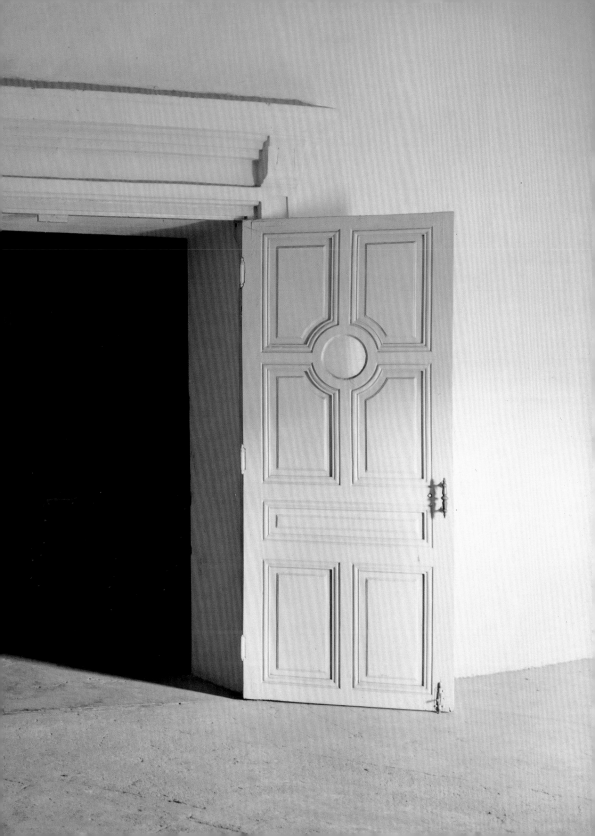

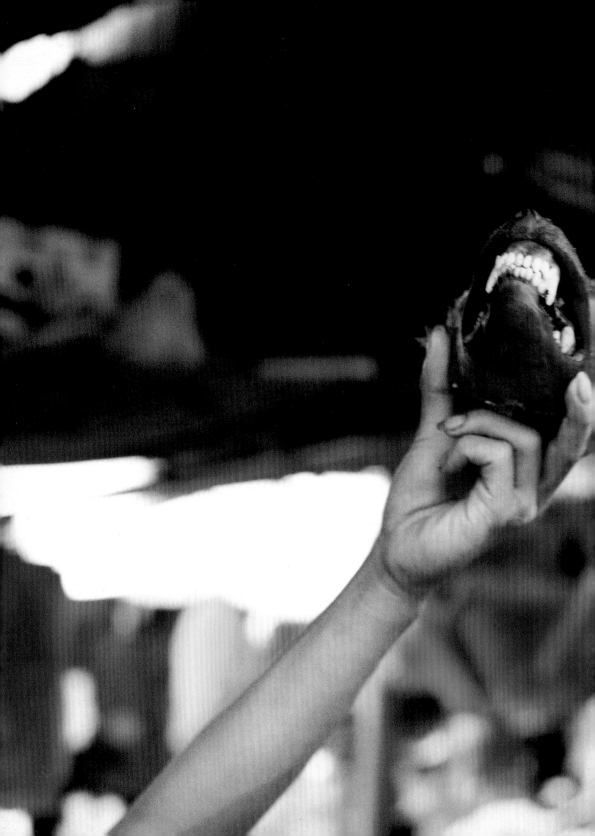

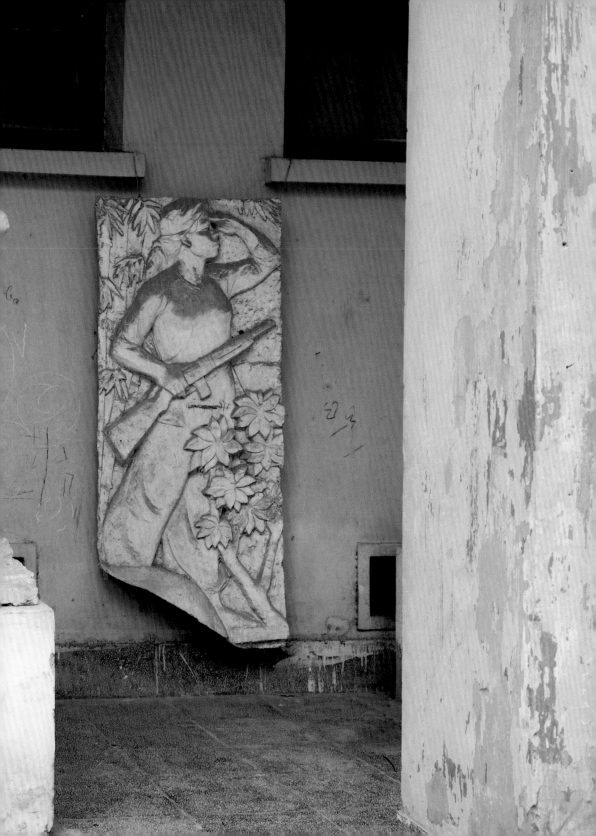

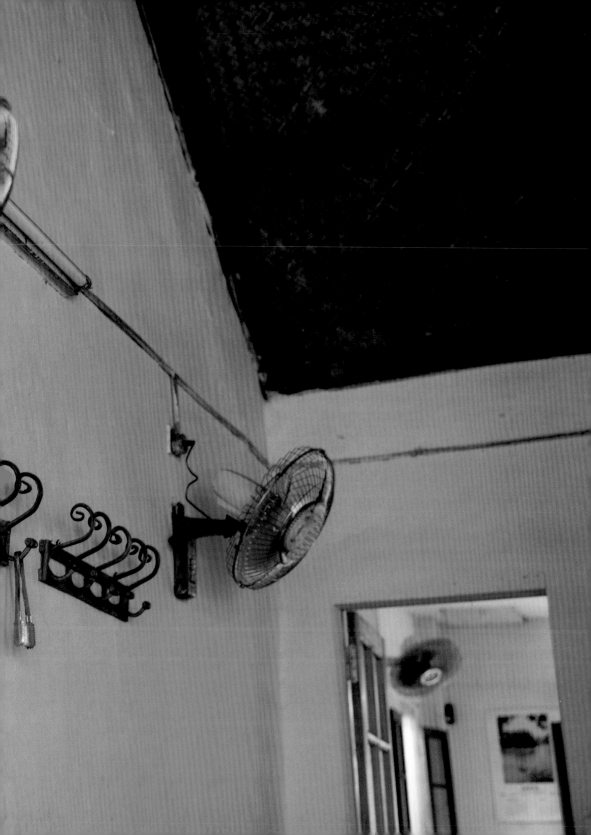

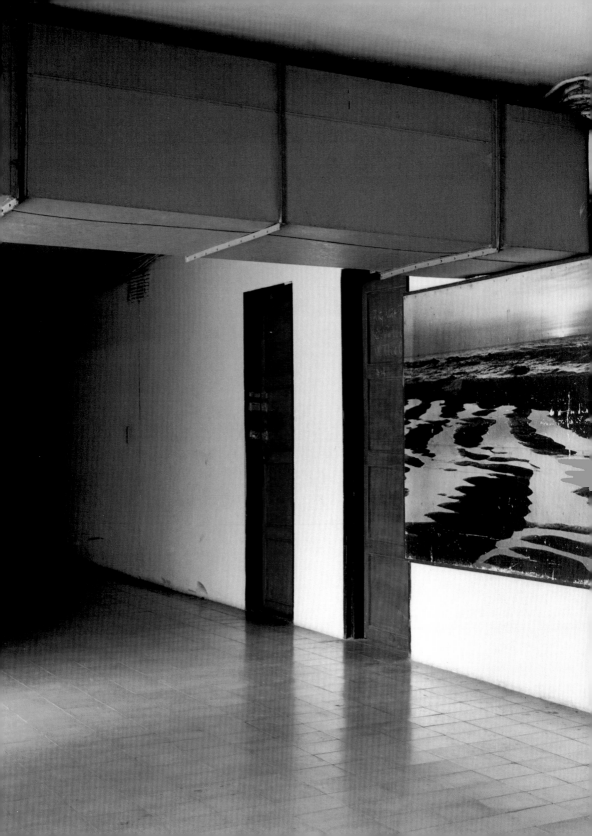

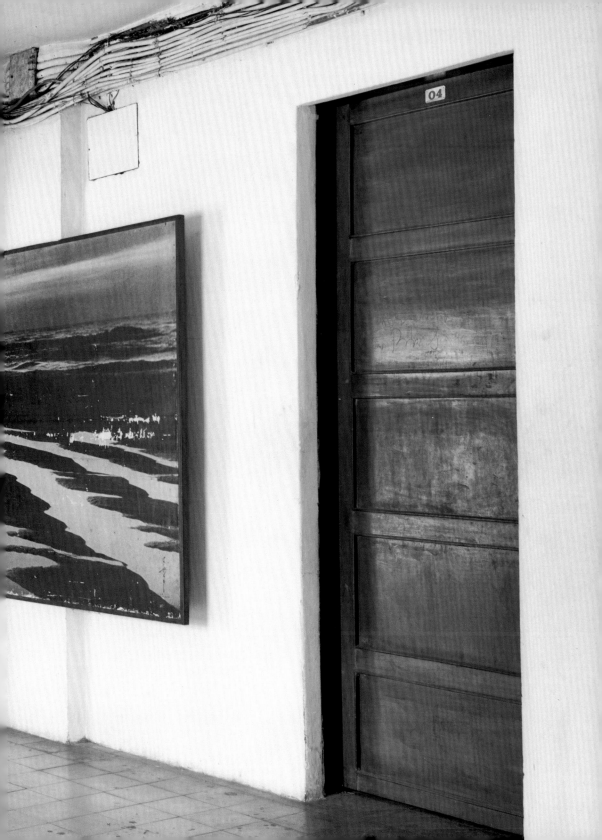

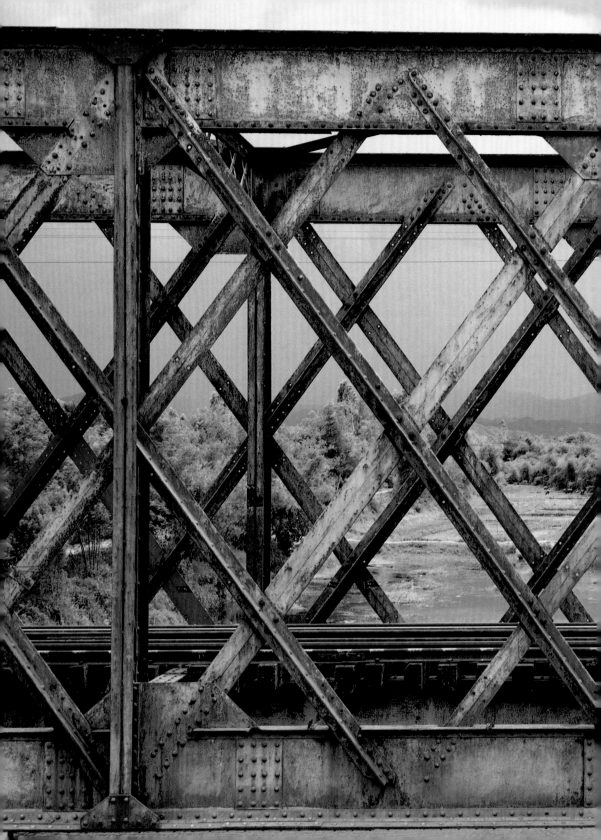

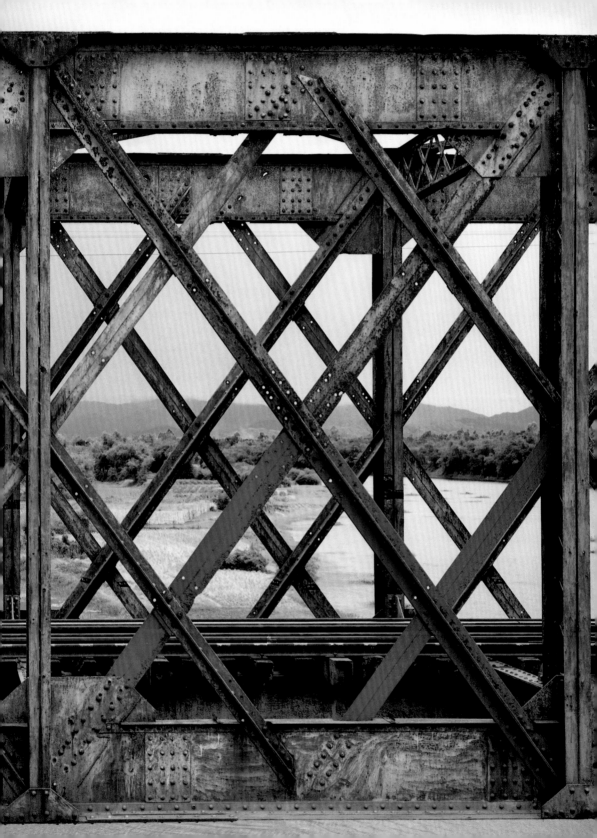

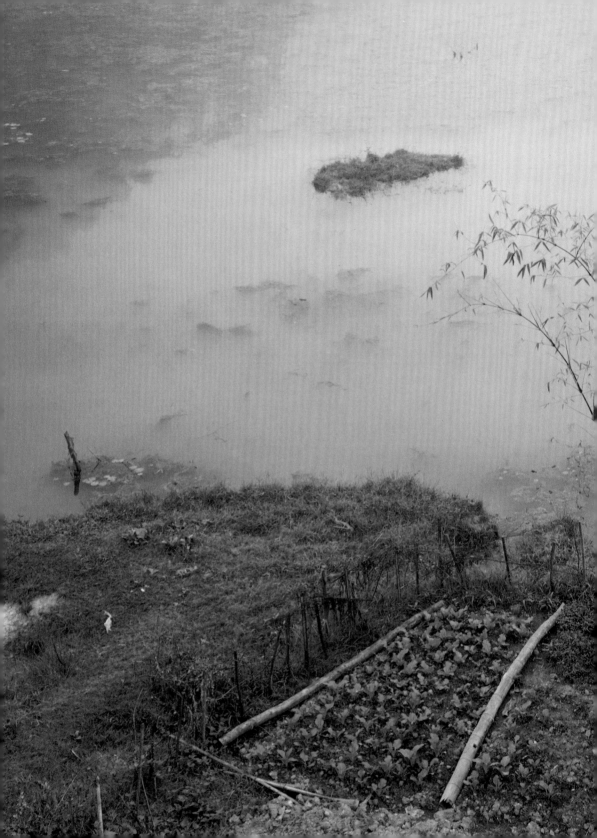

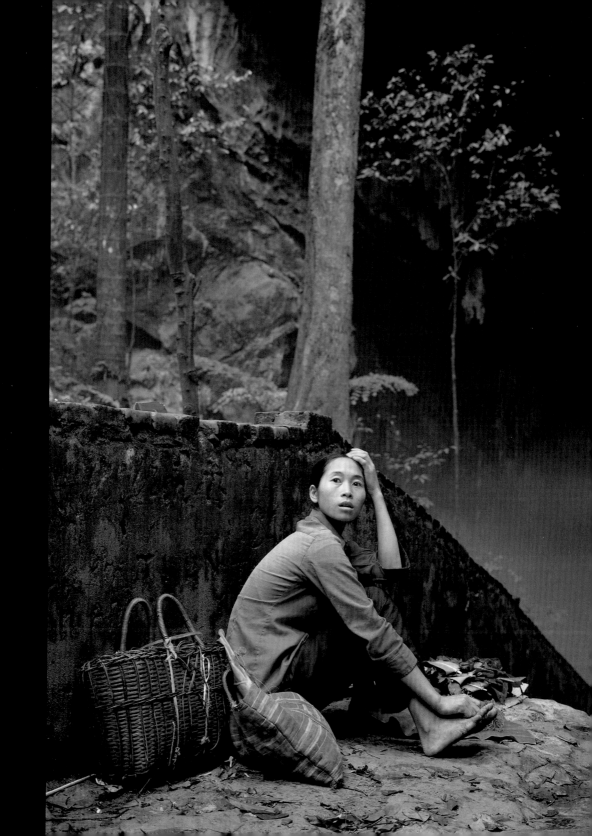

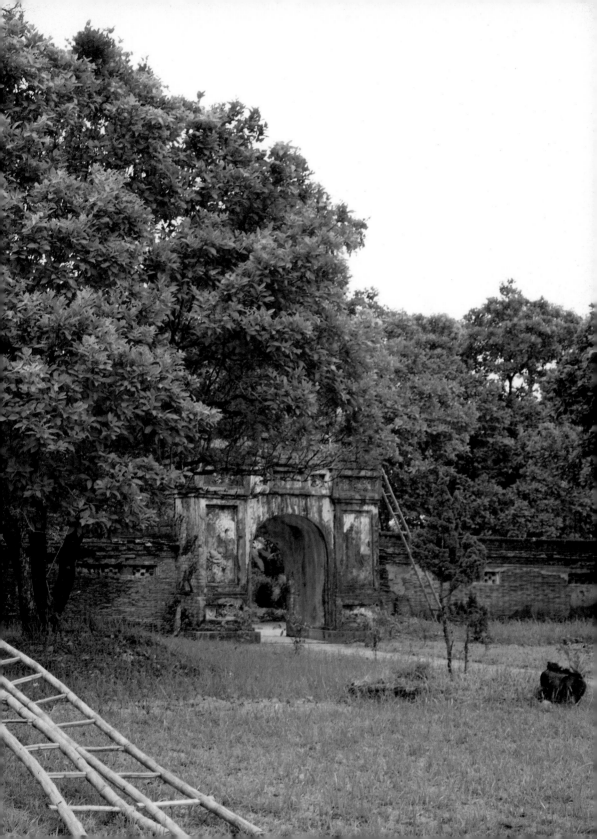

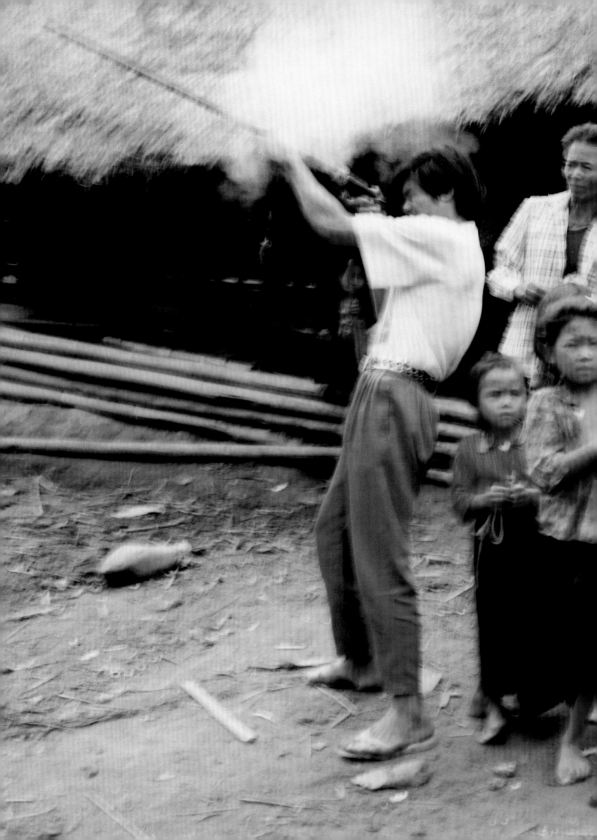

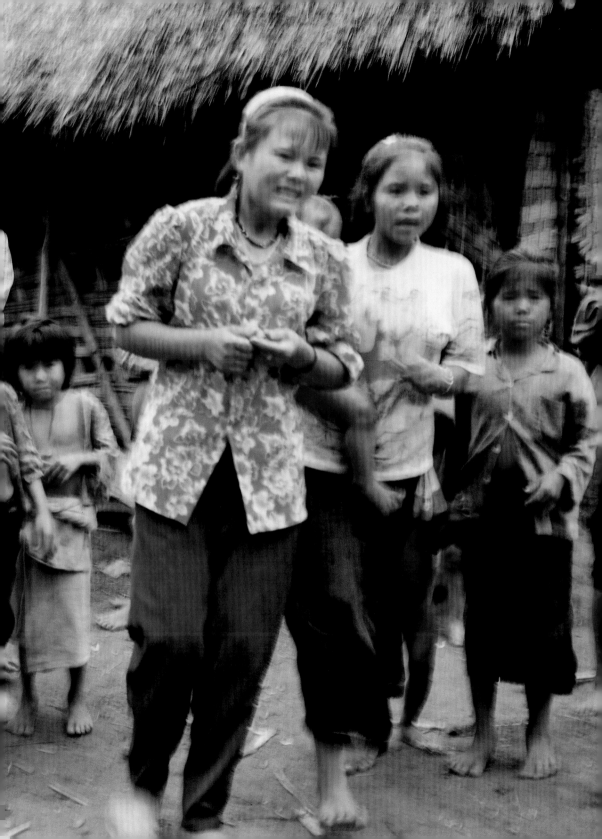

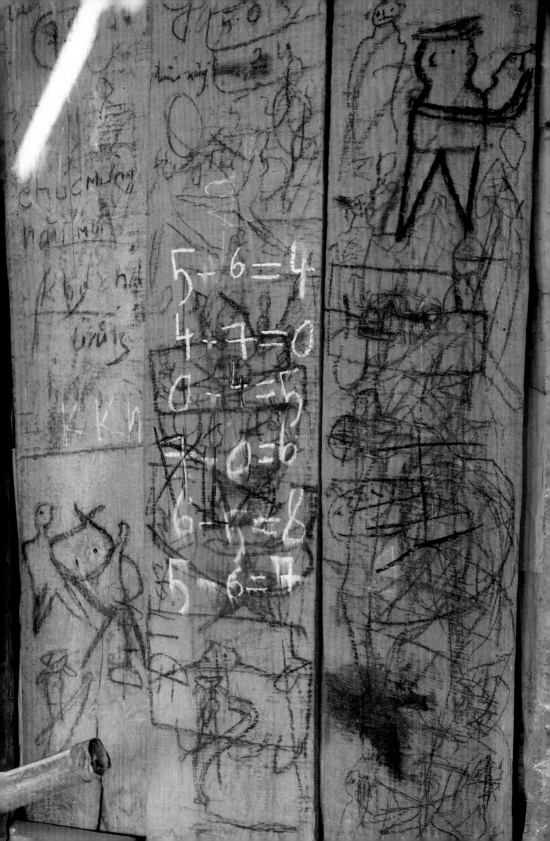

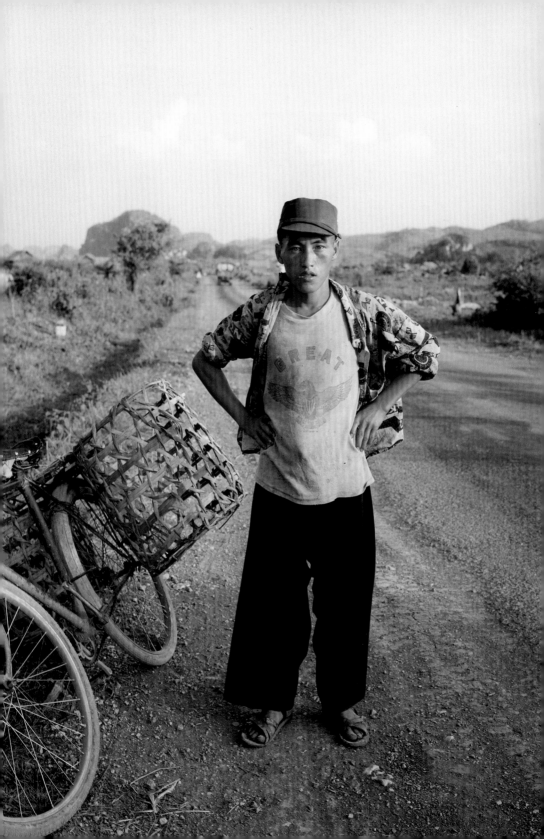

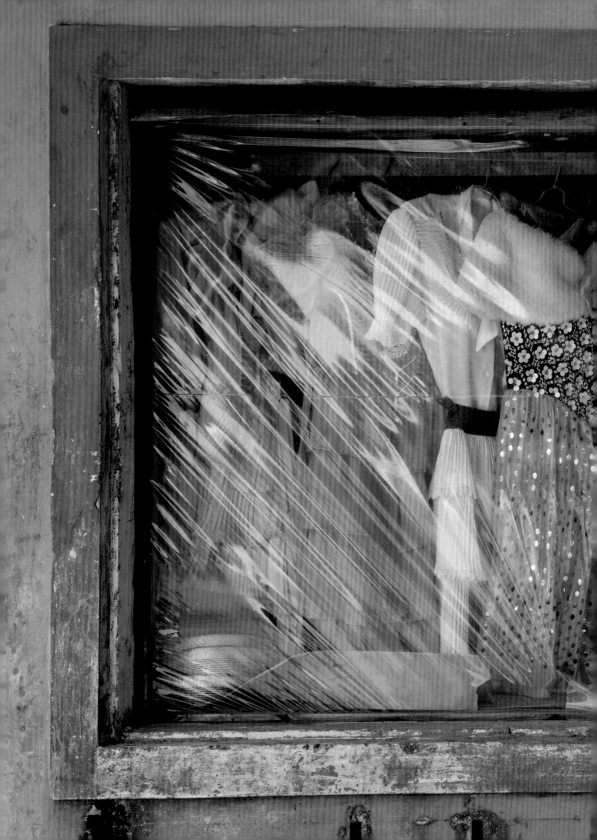

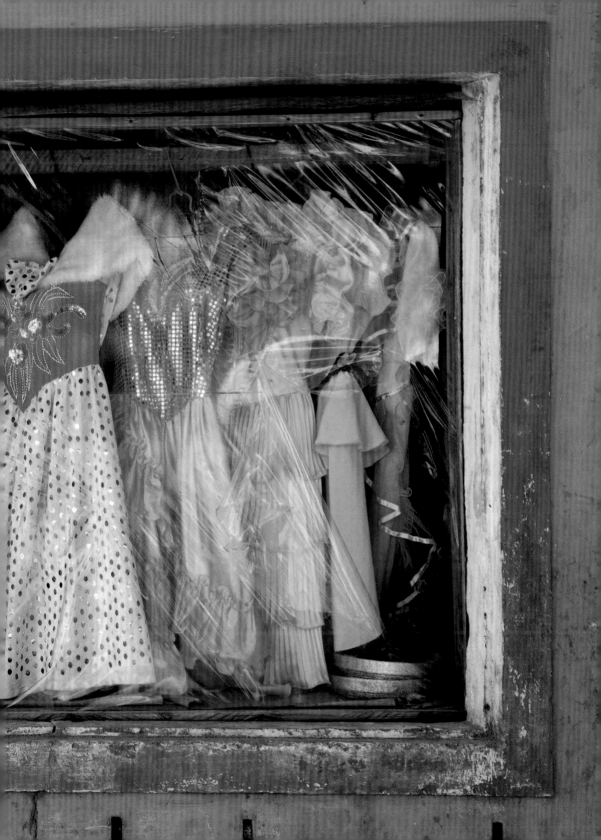

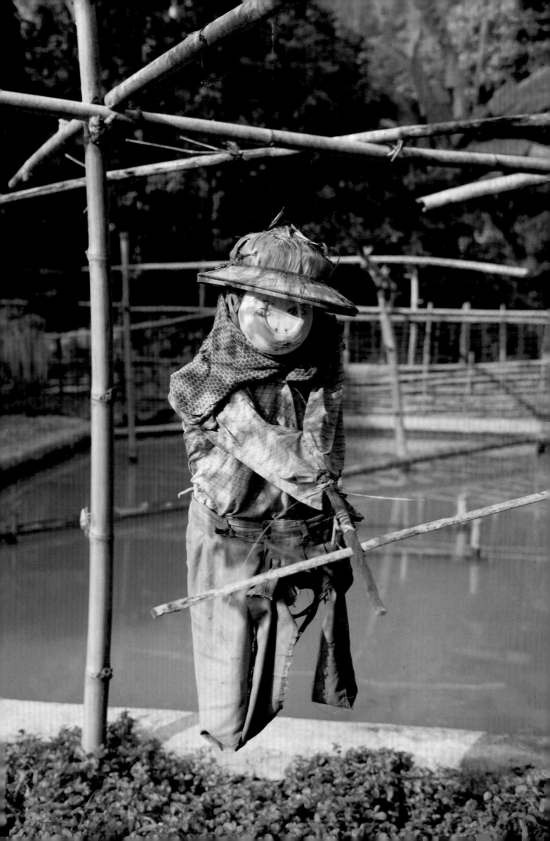

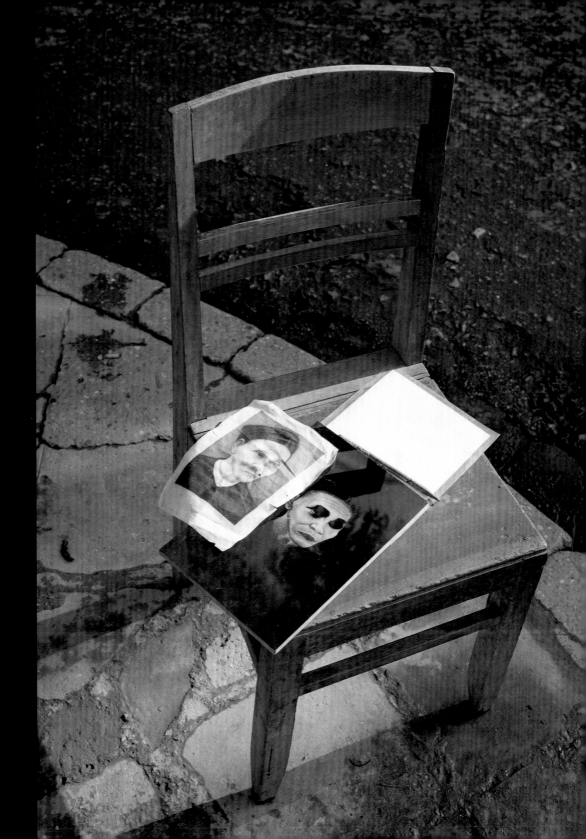

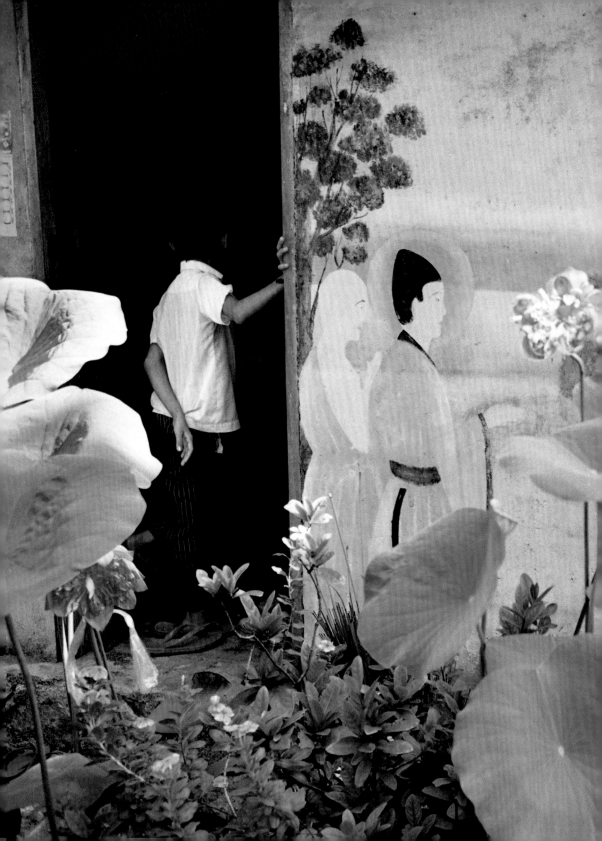

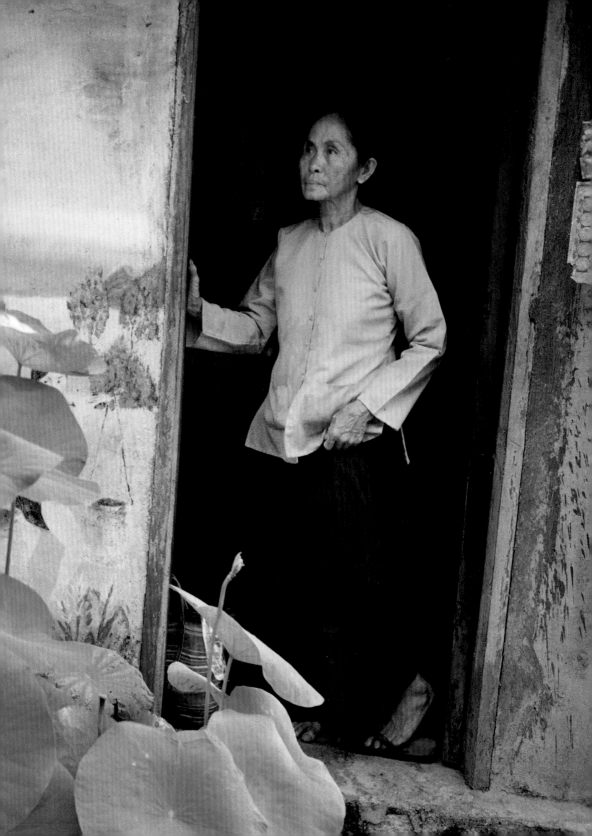

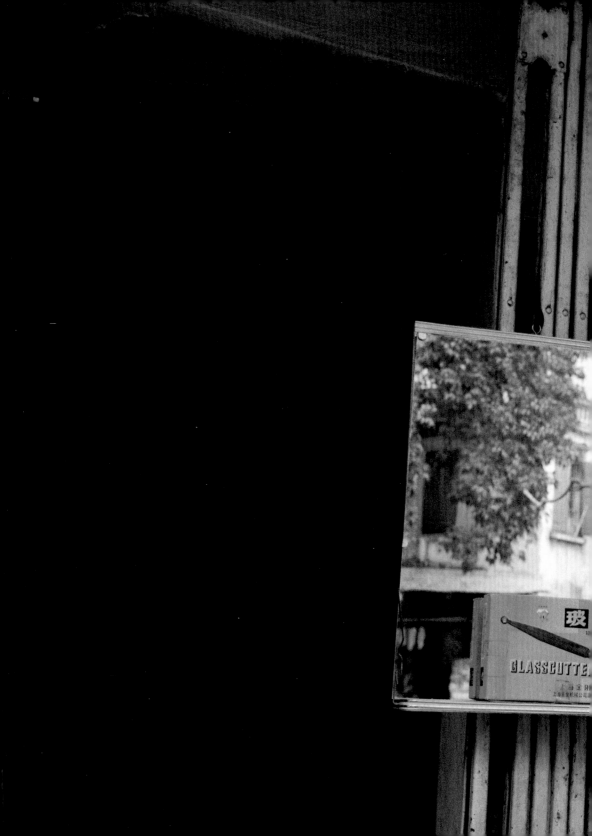

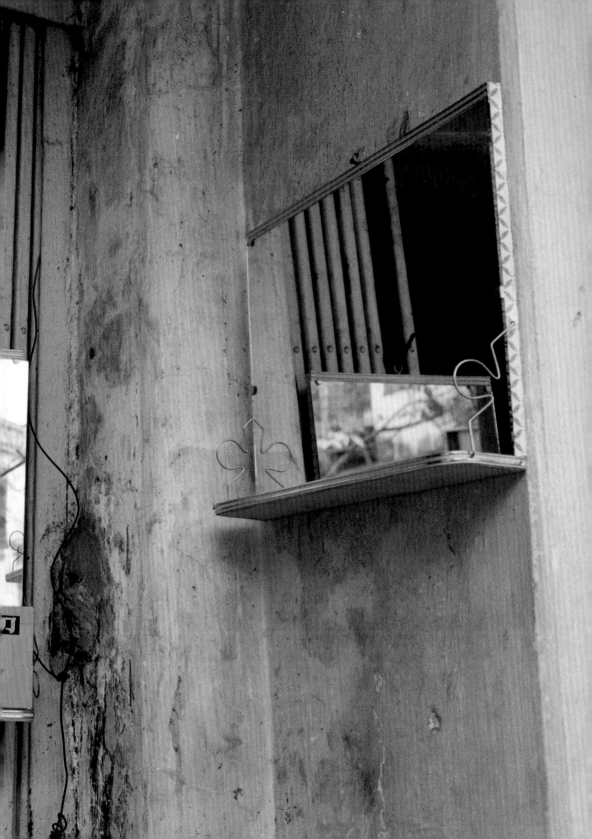

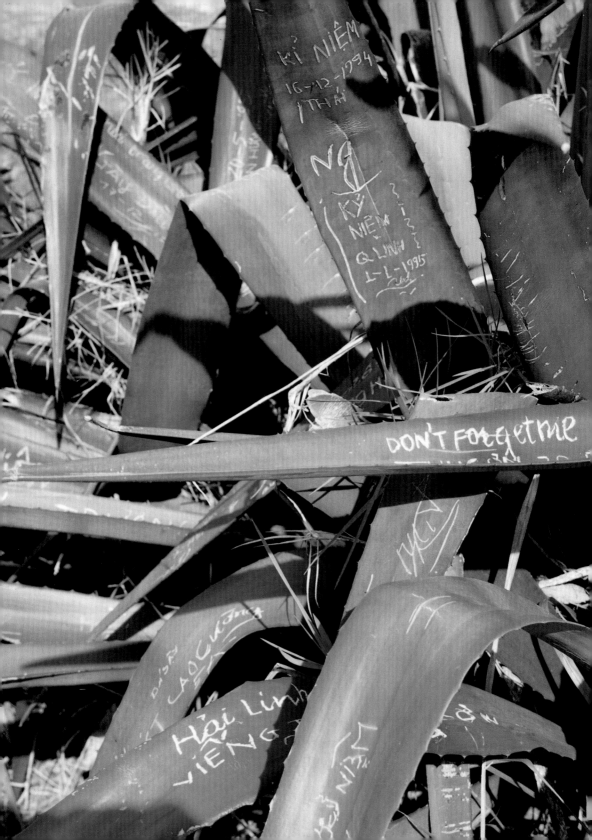

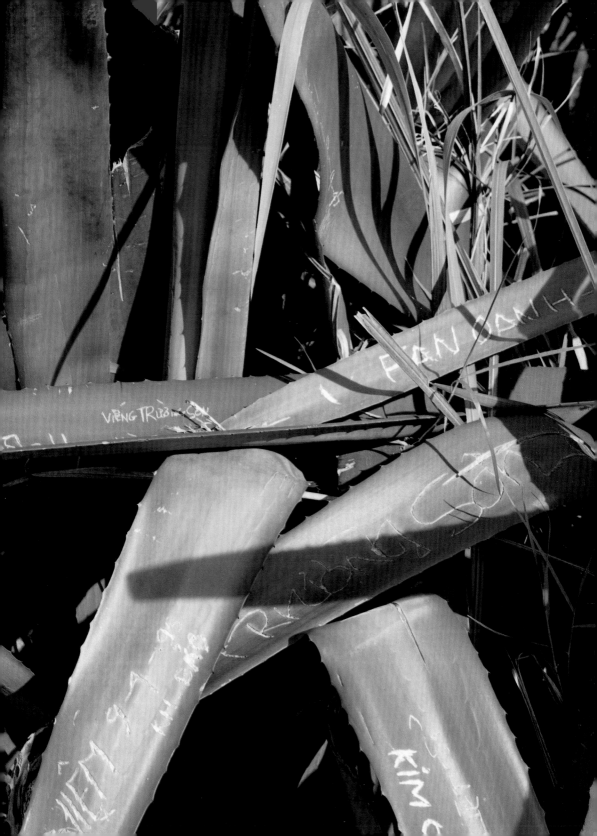

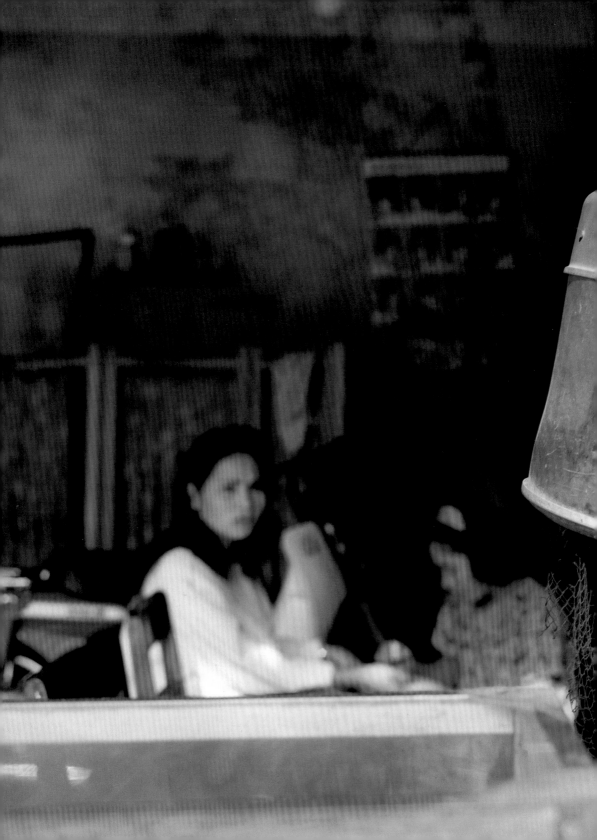

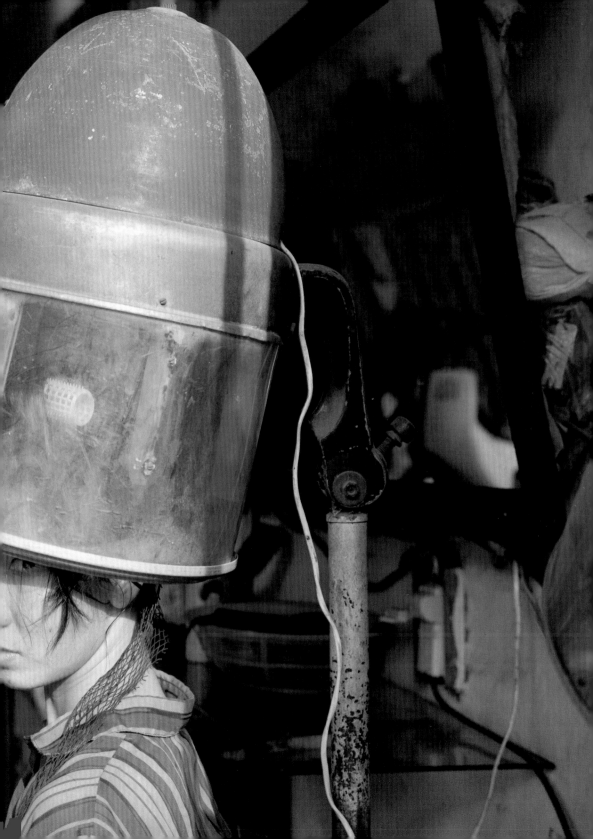

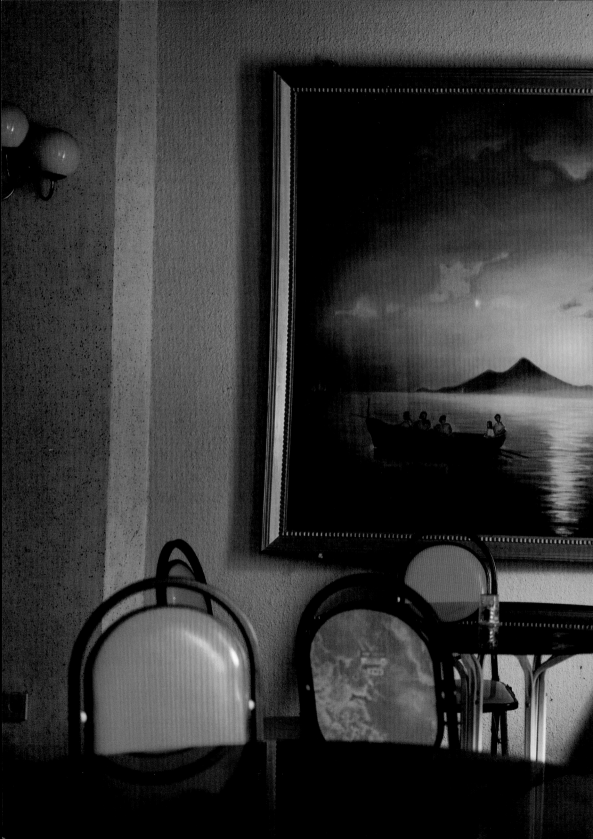

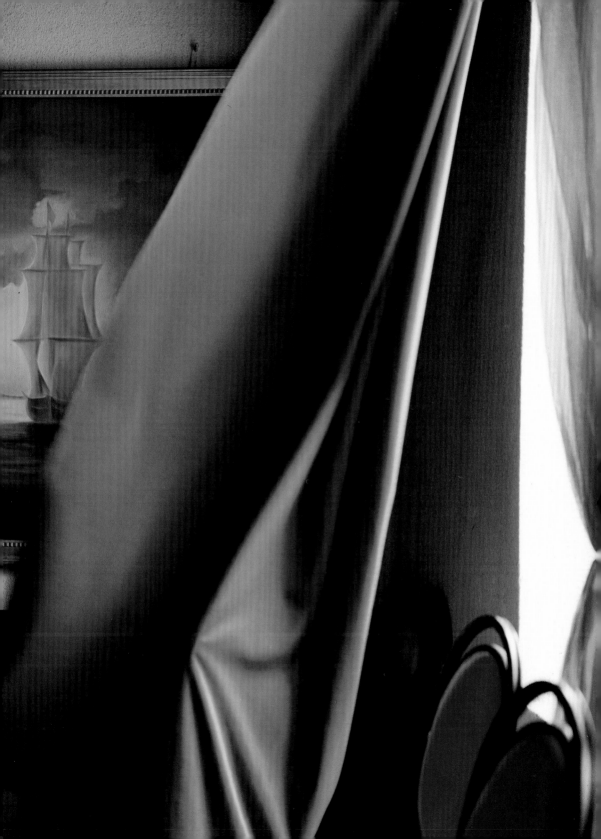

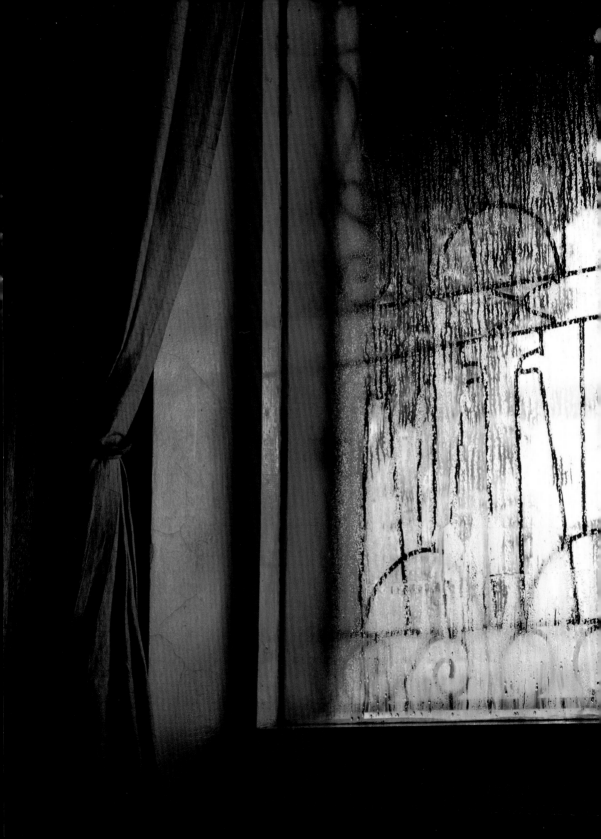

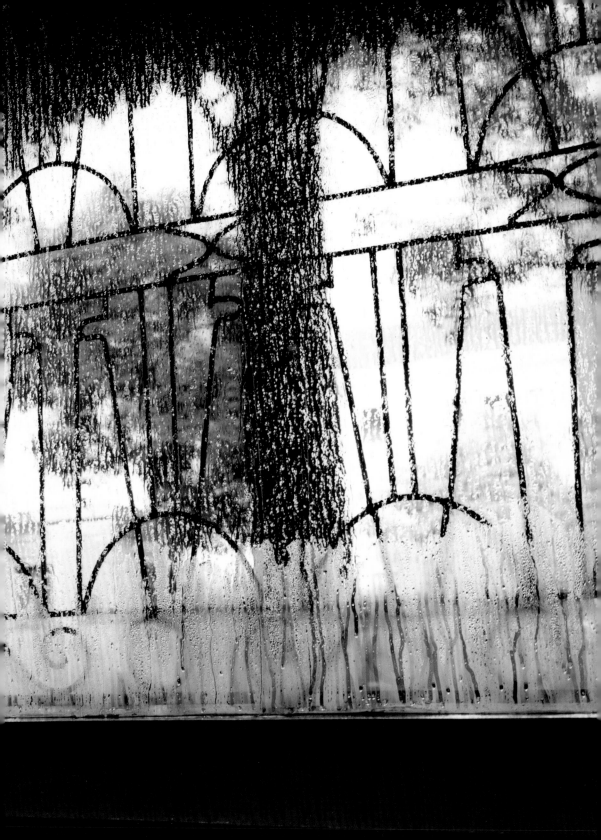

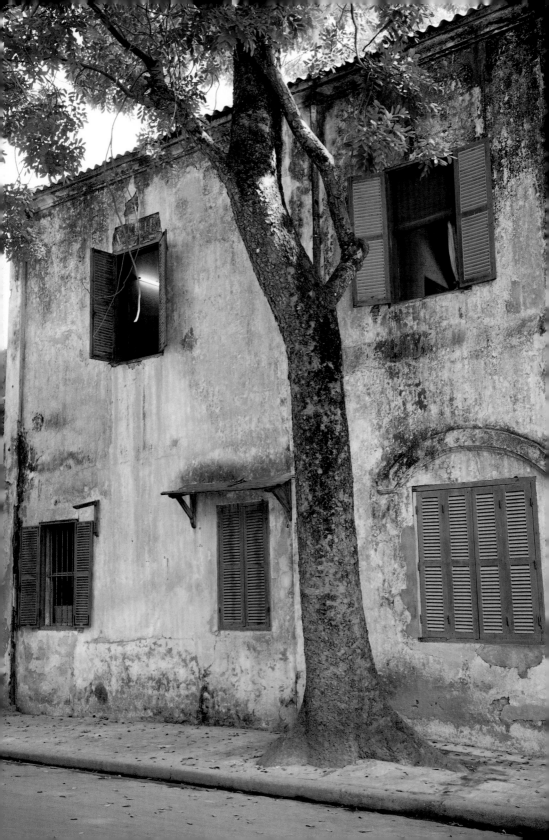

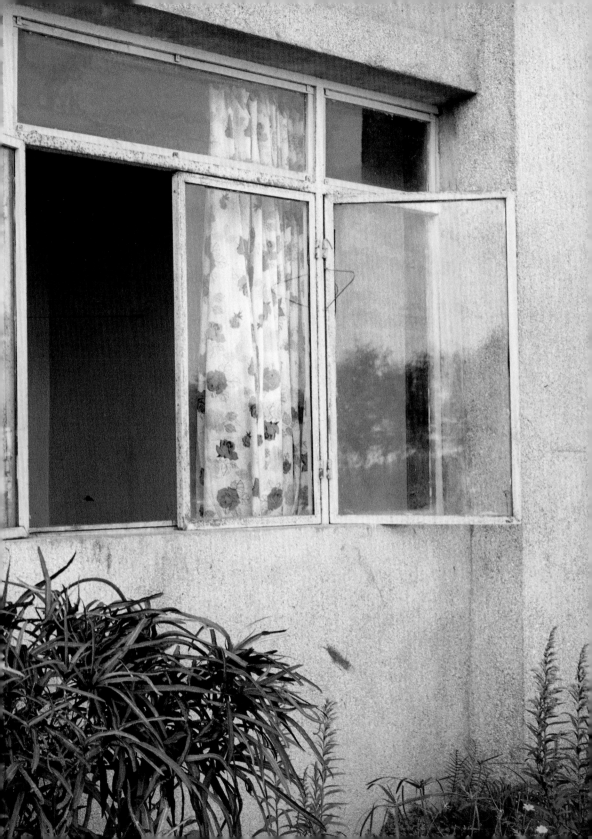

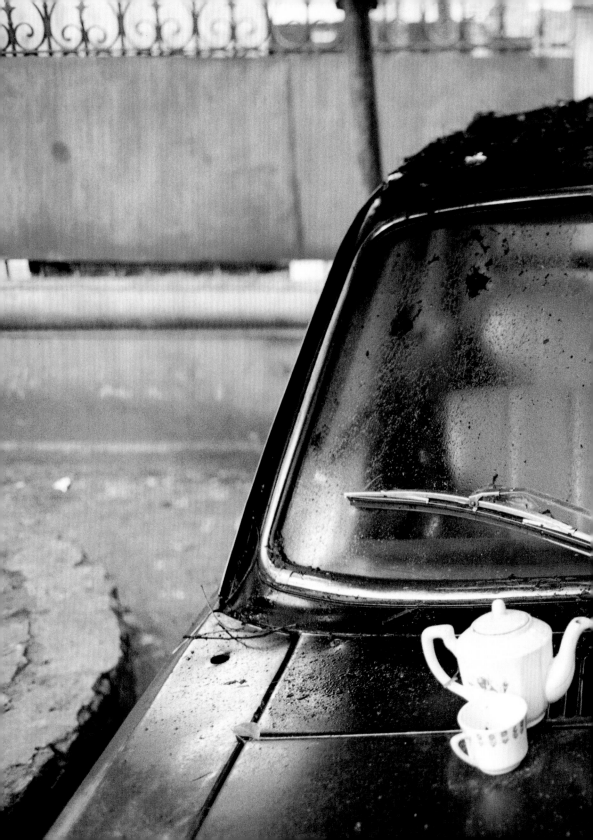

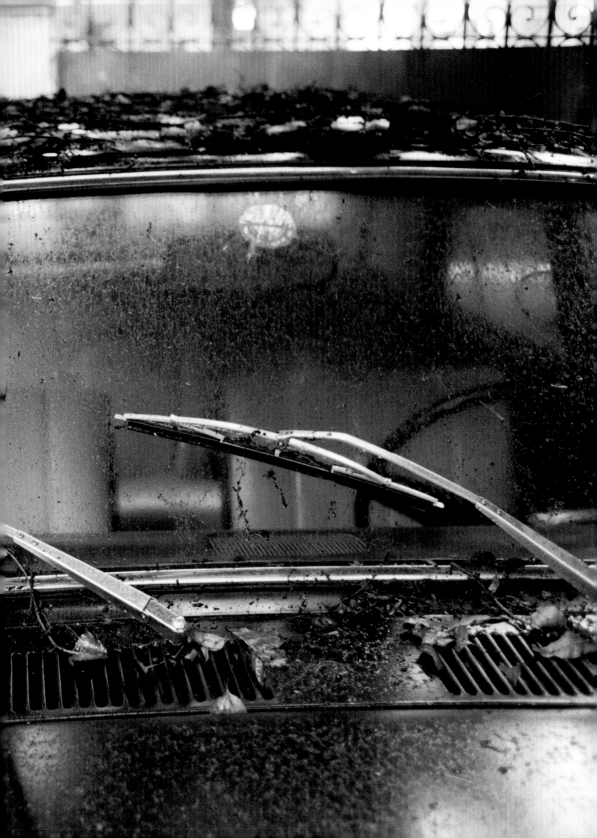

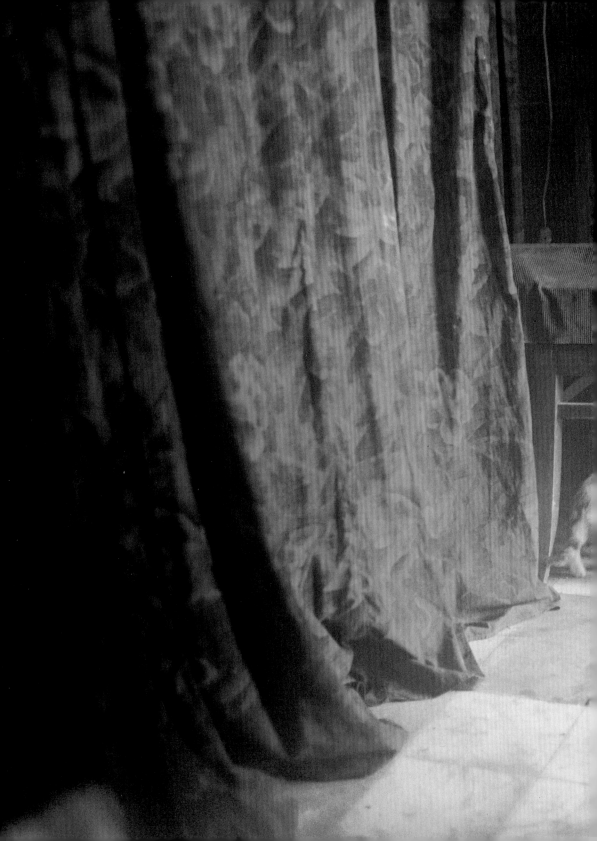

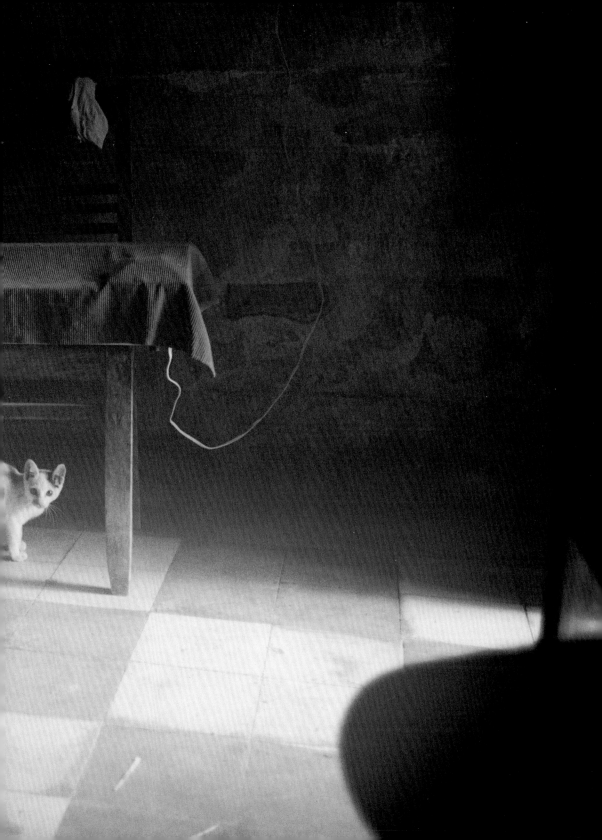

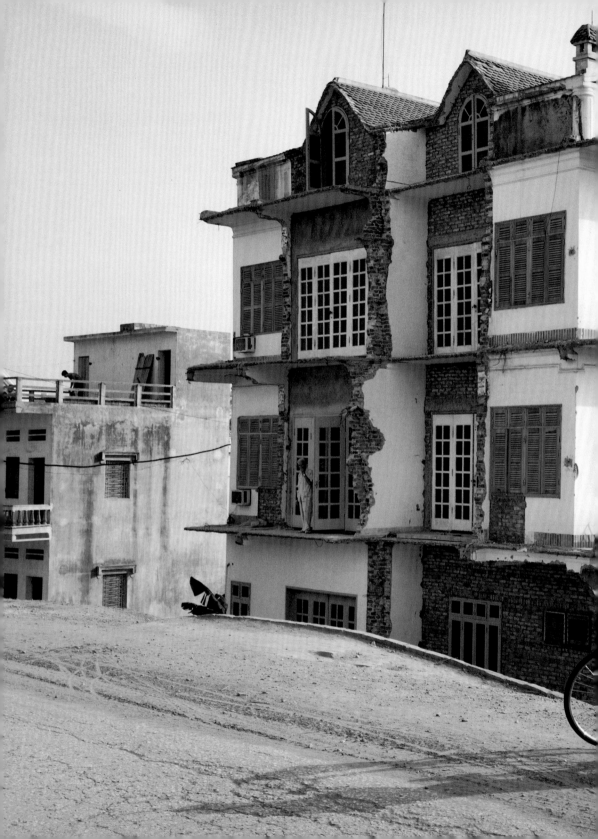

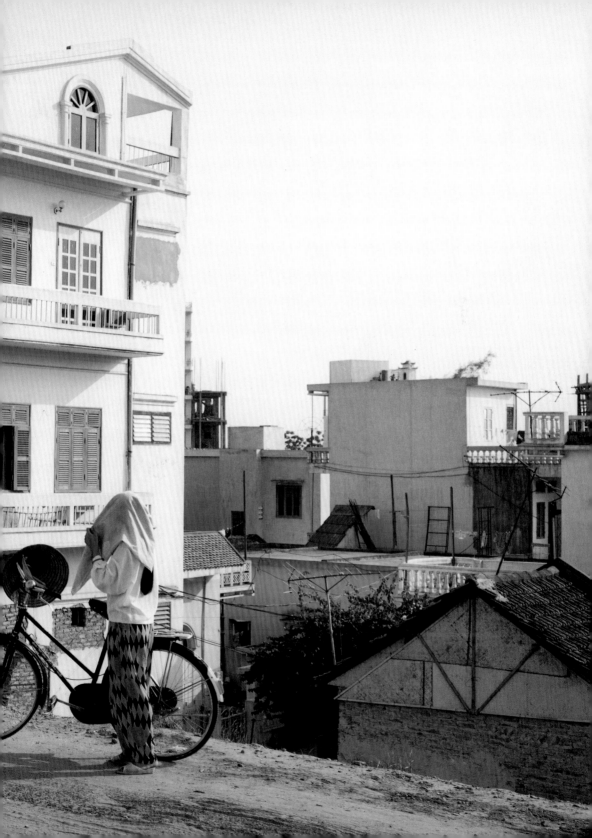

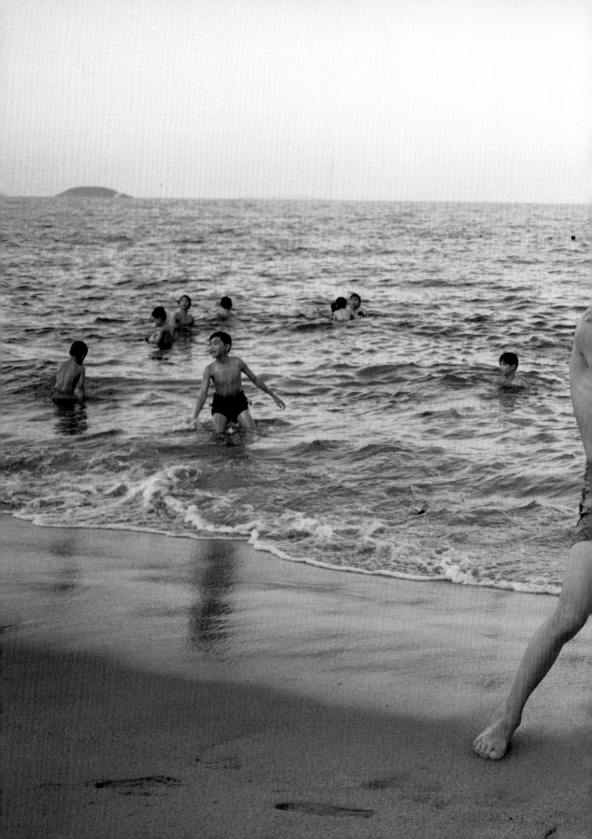

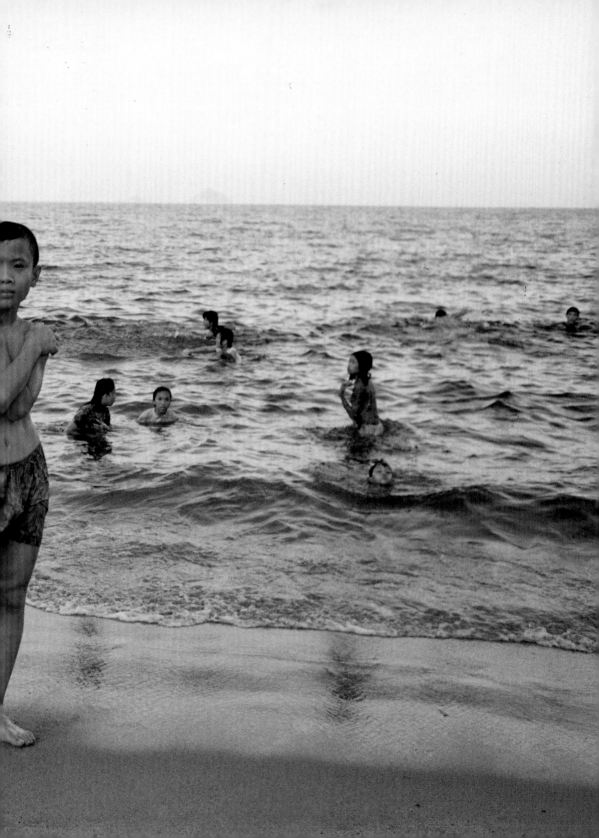

III

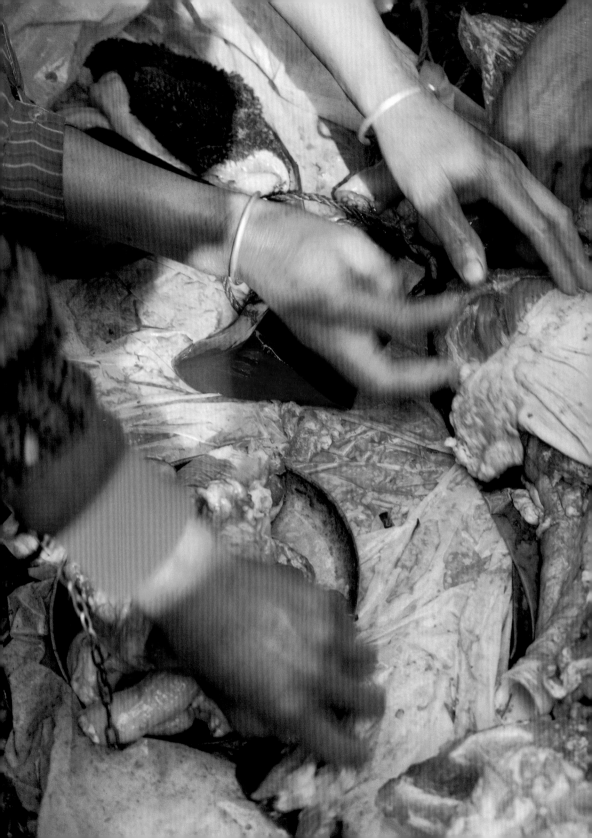

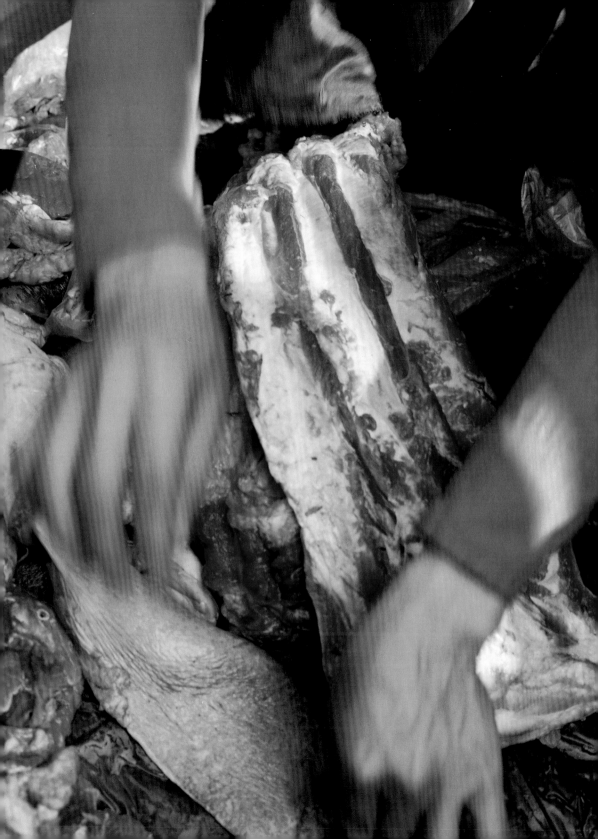

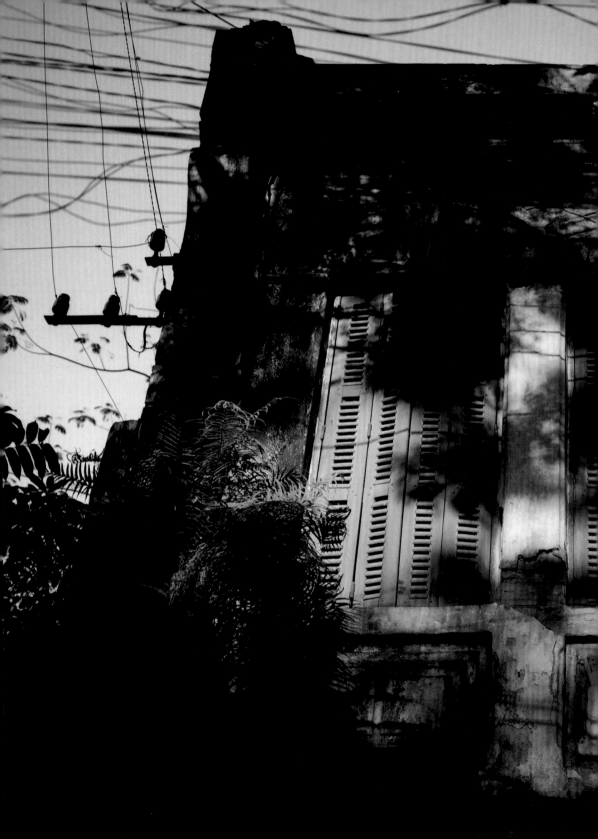

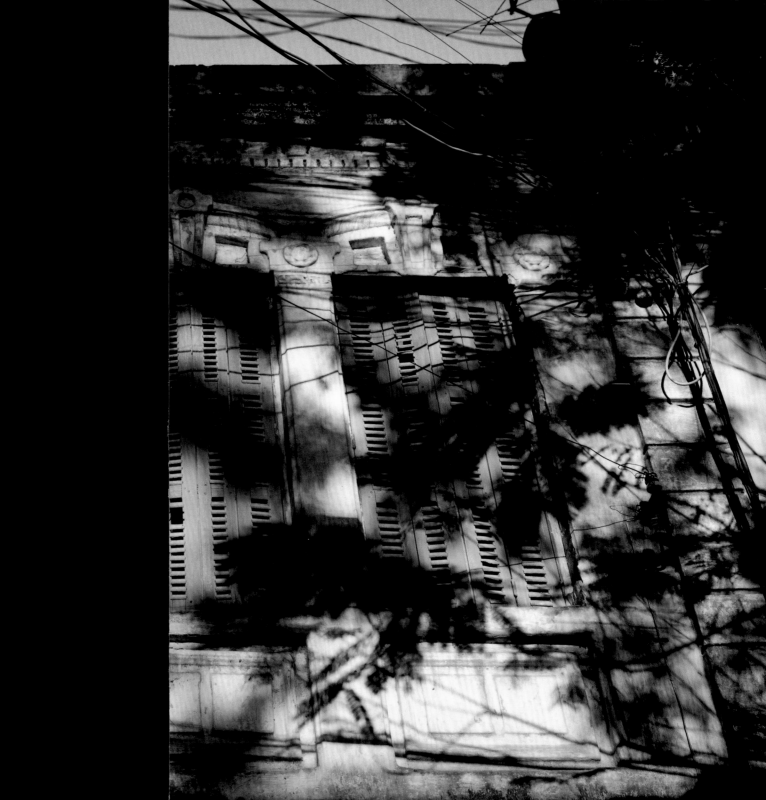

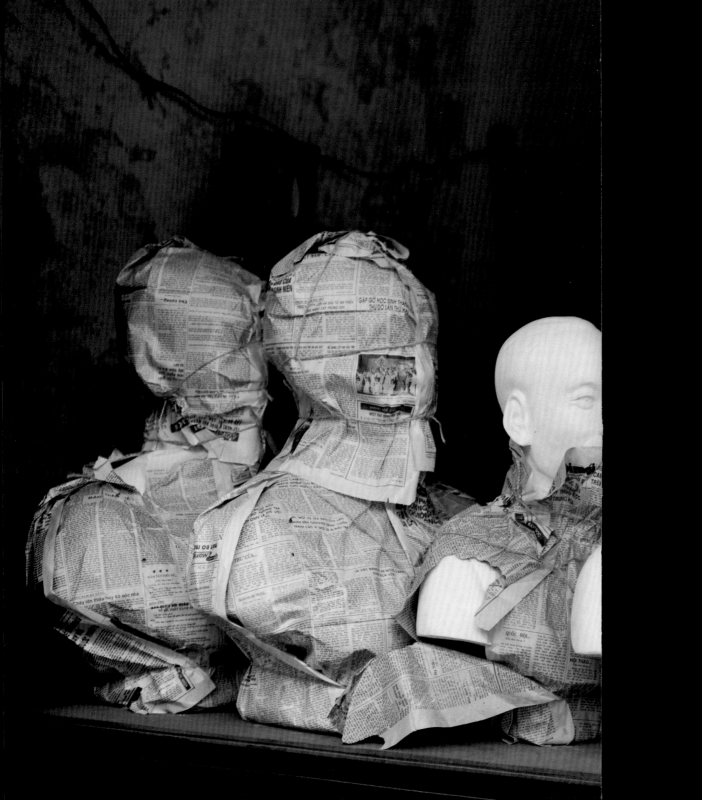

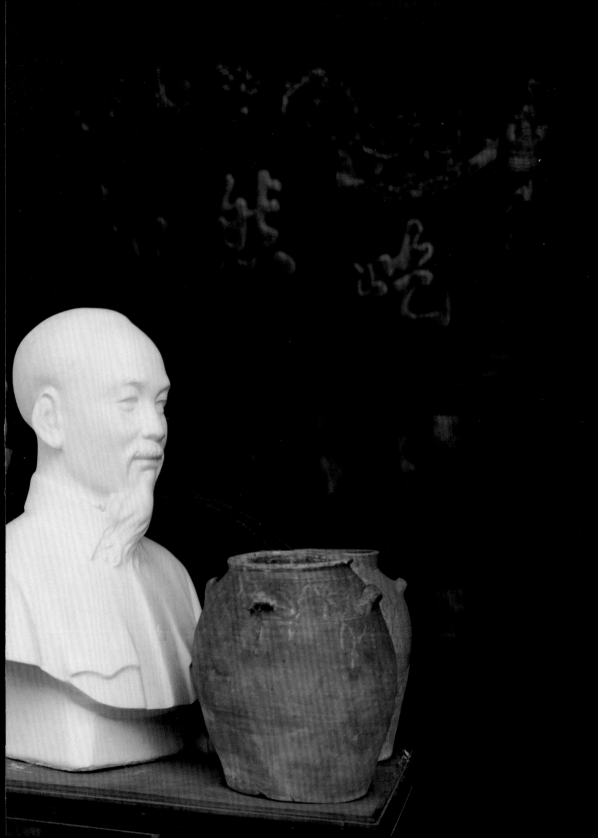

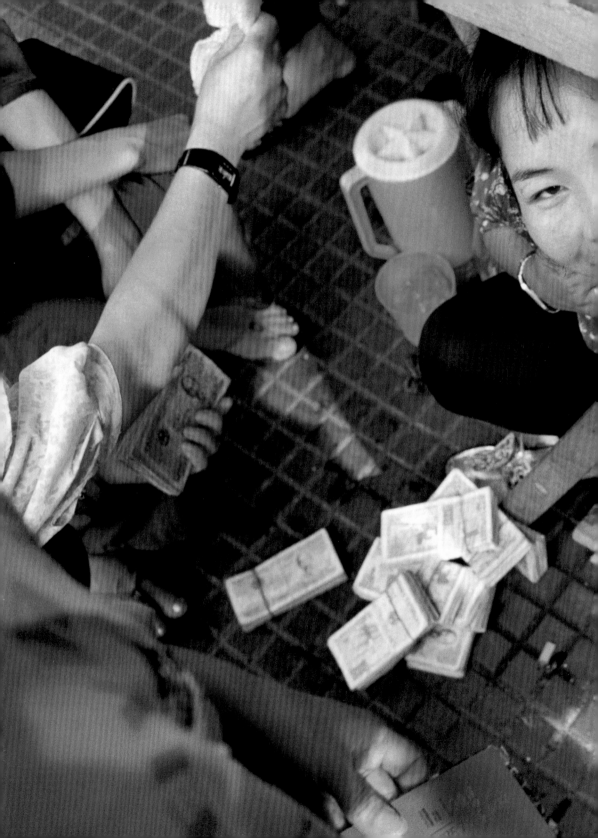

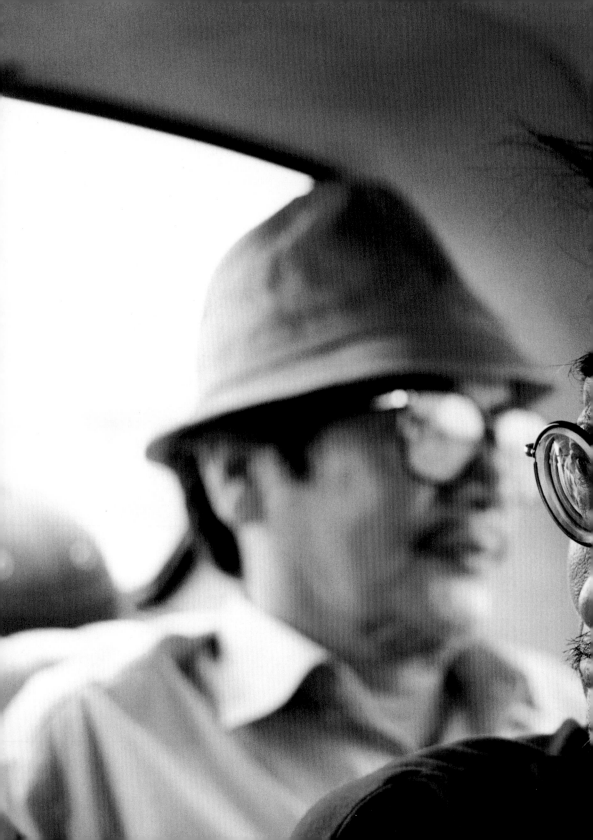

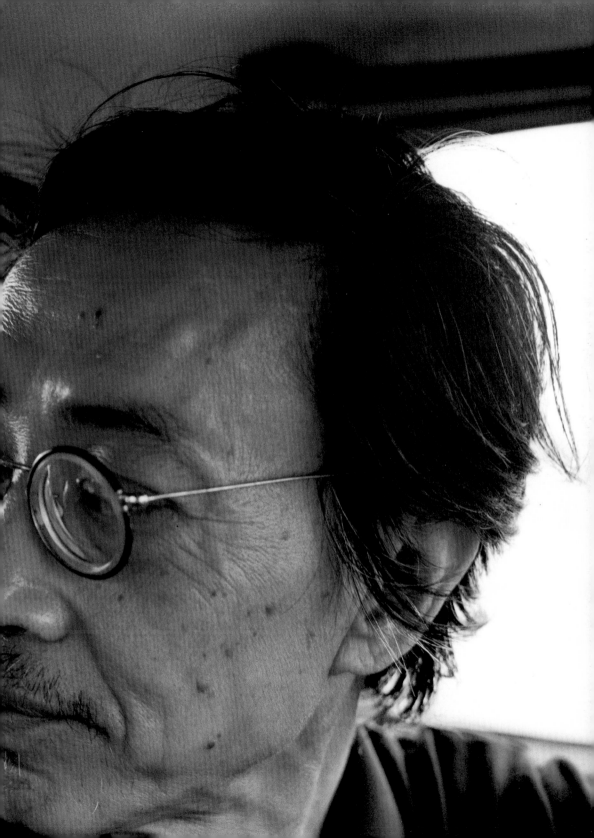

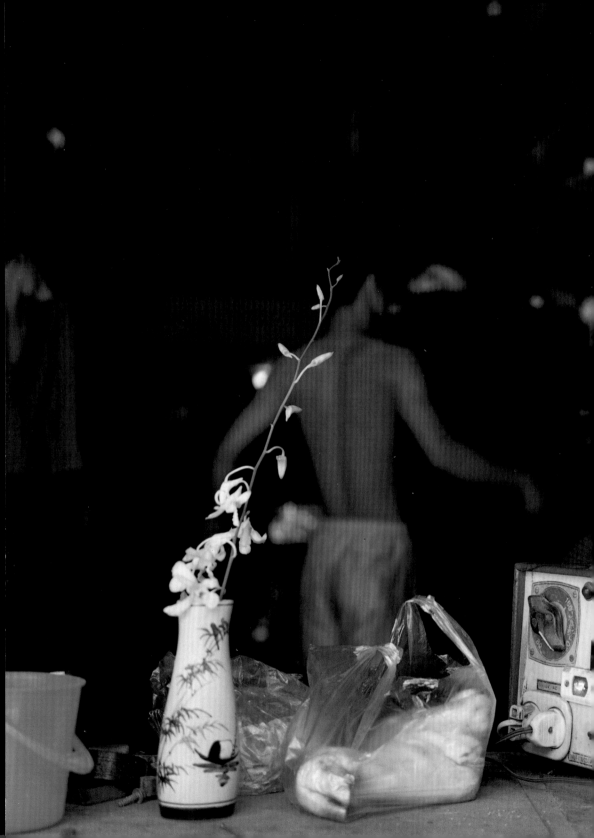

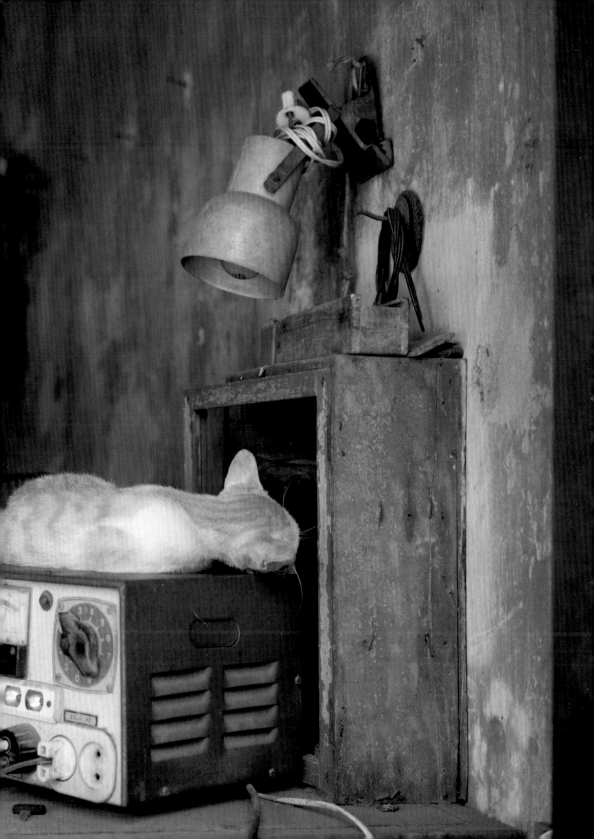

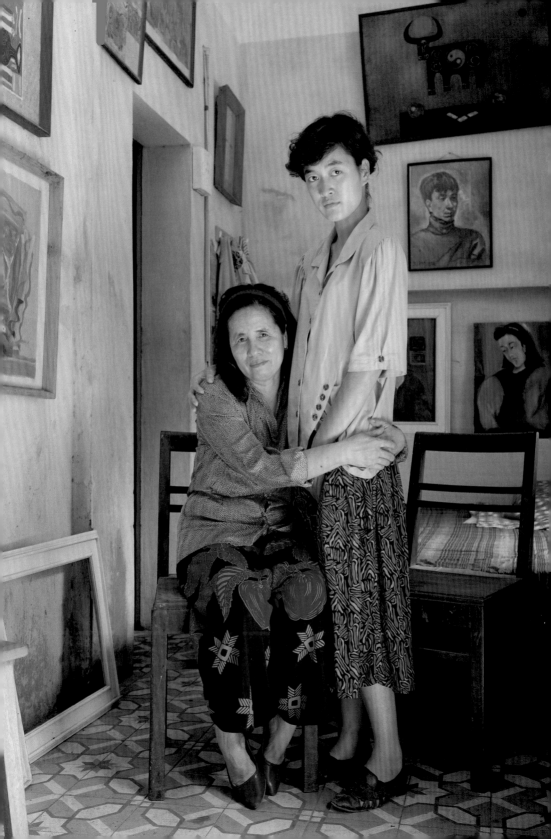

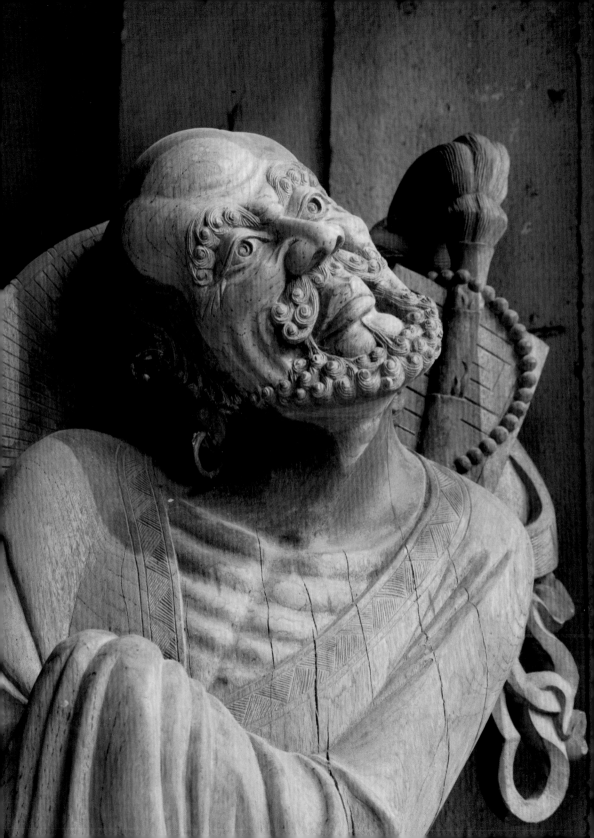

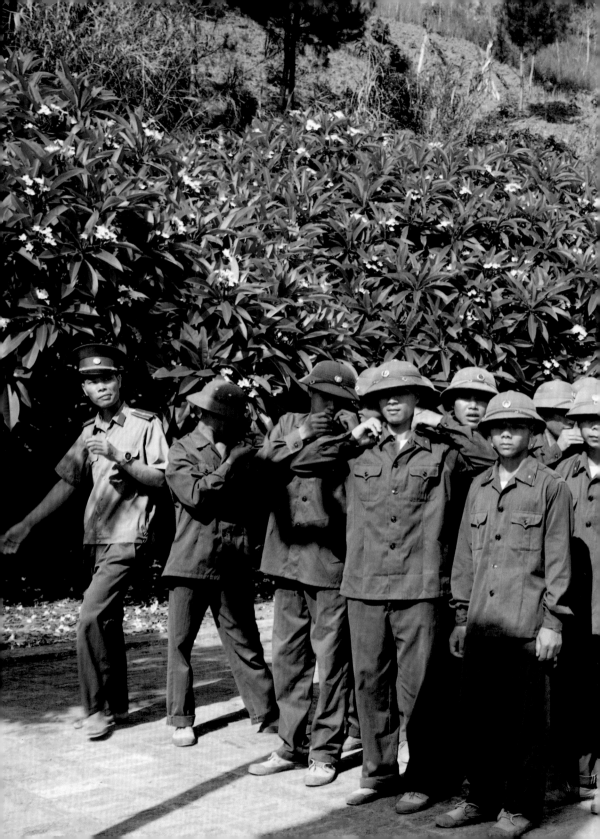

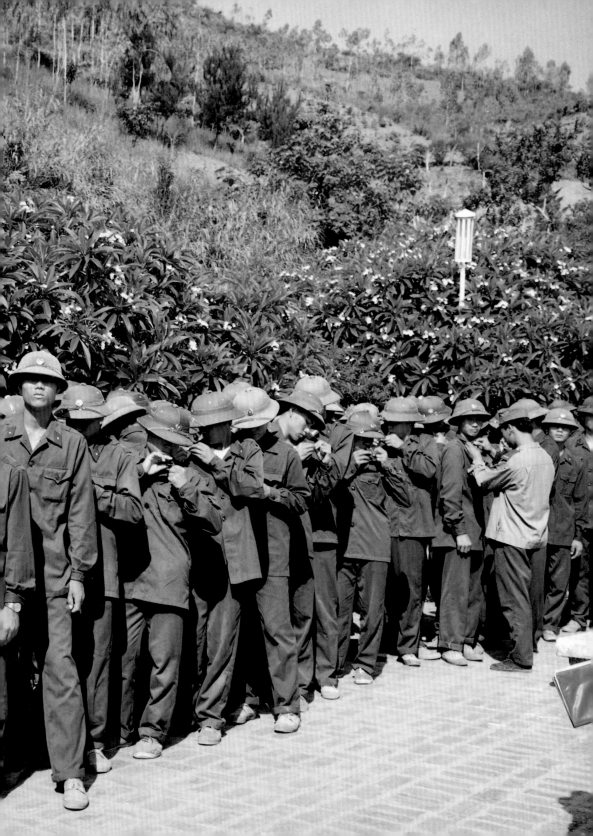

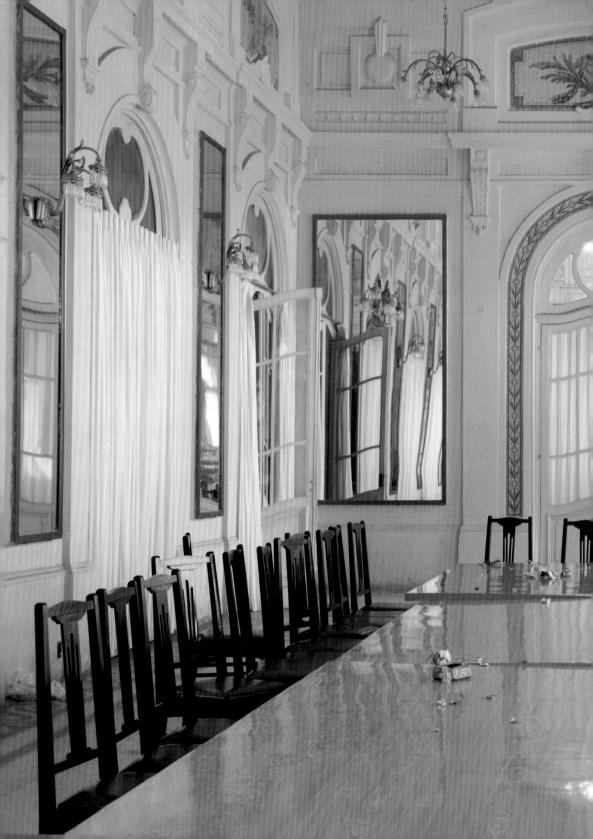

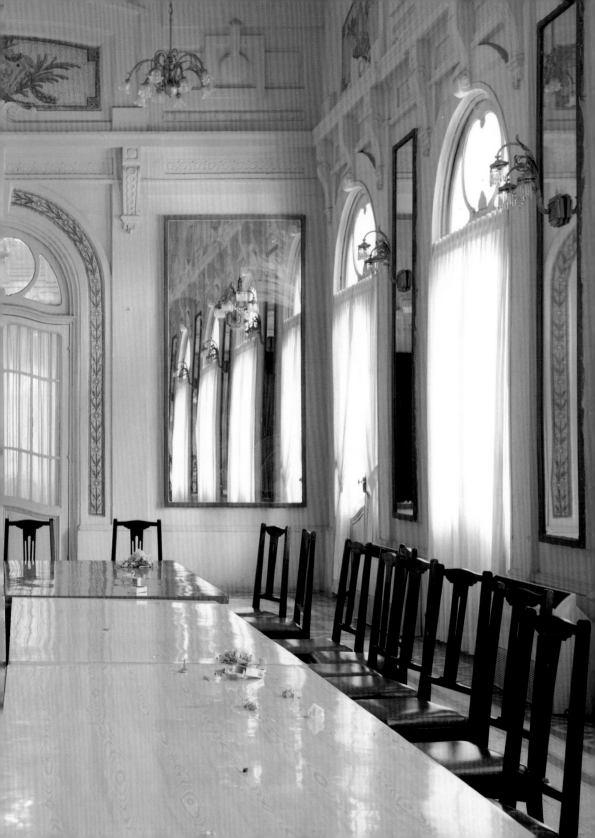

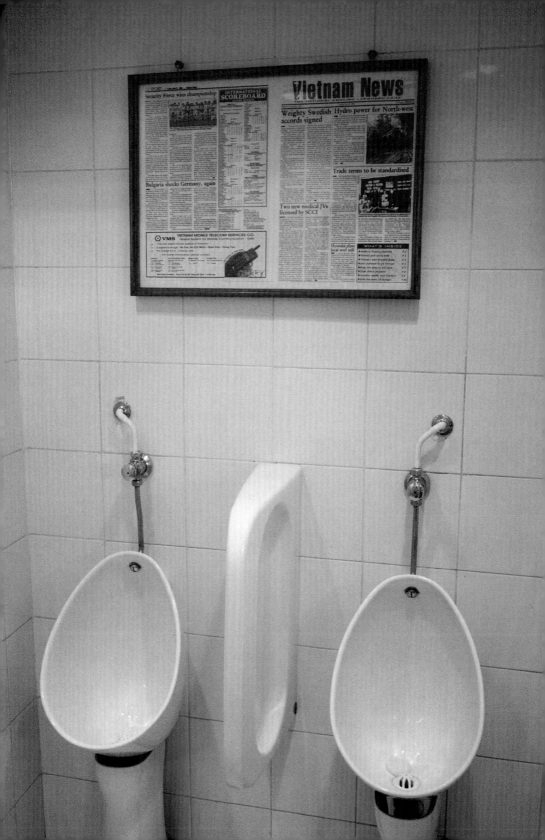

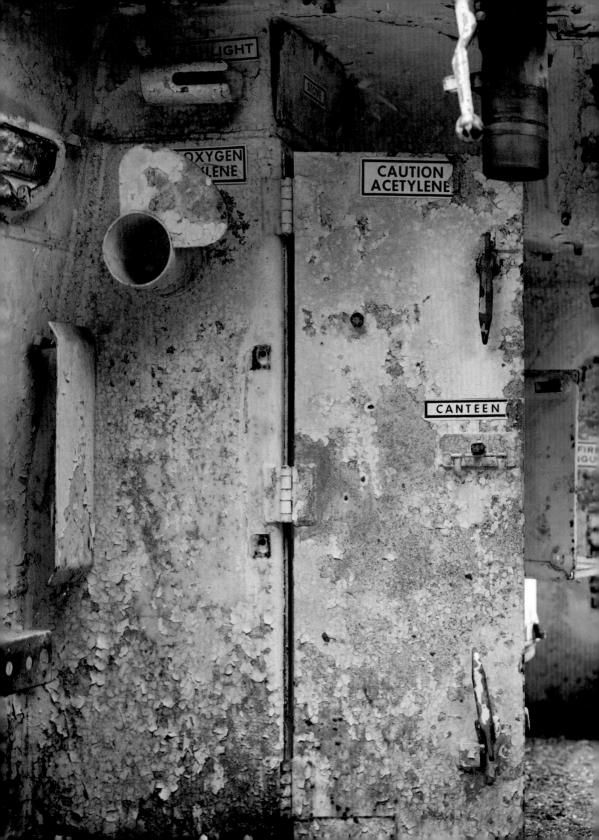

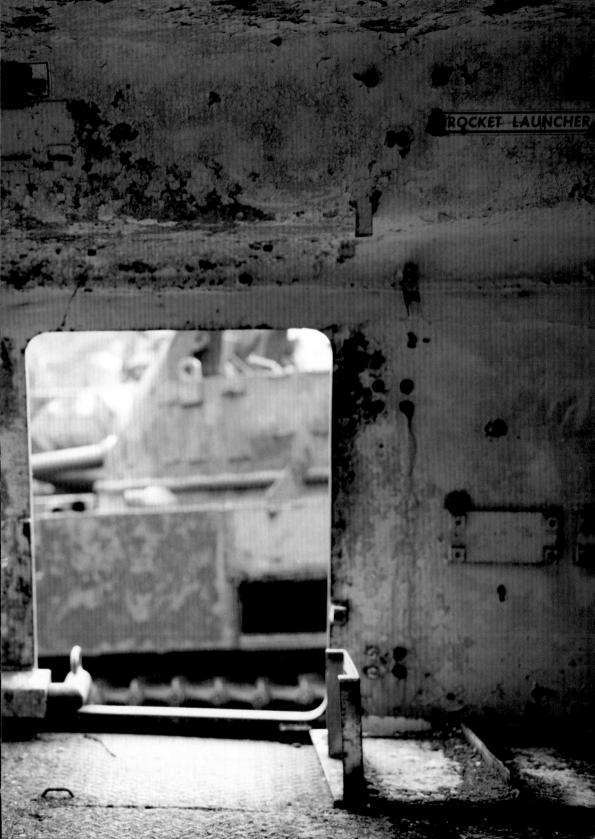

ROCKET LAUNCHER

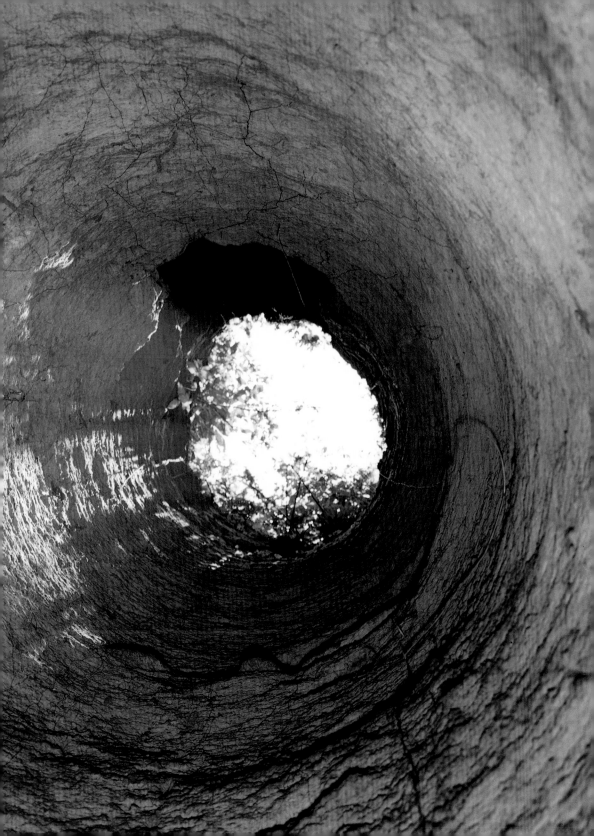

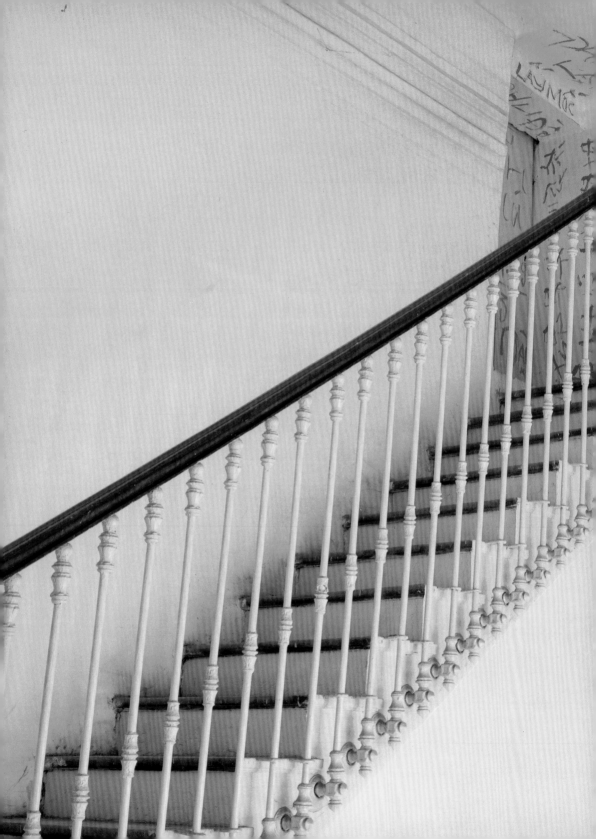

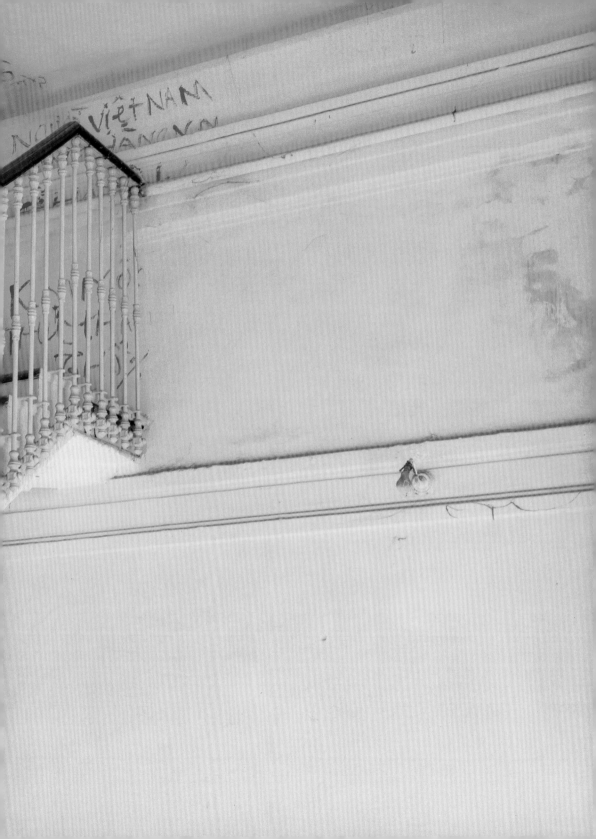

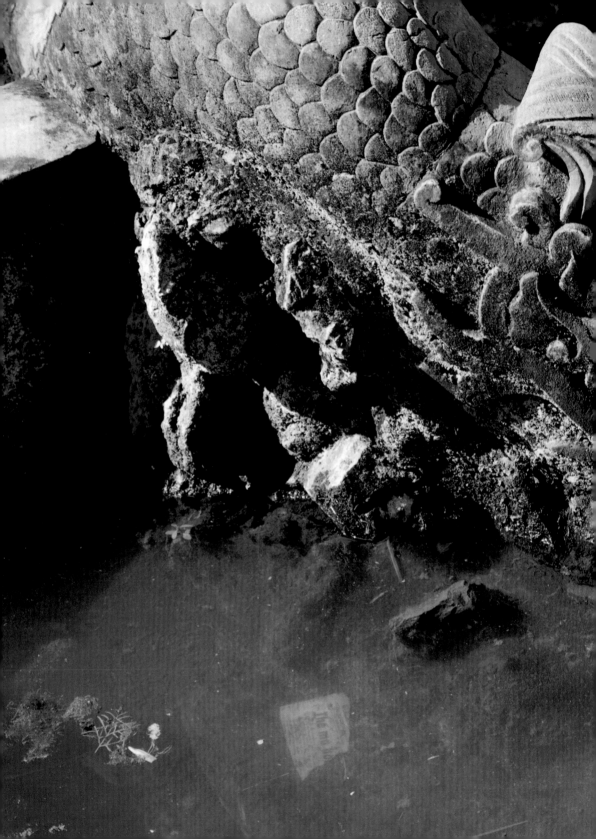

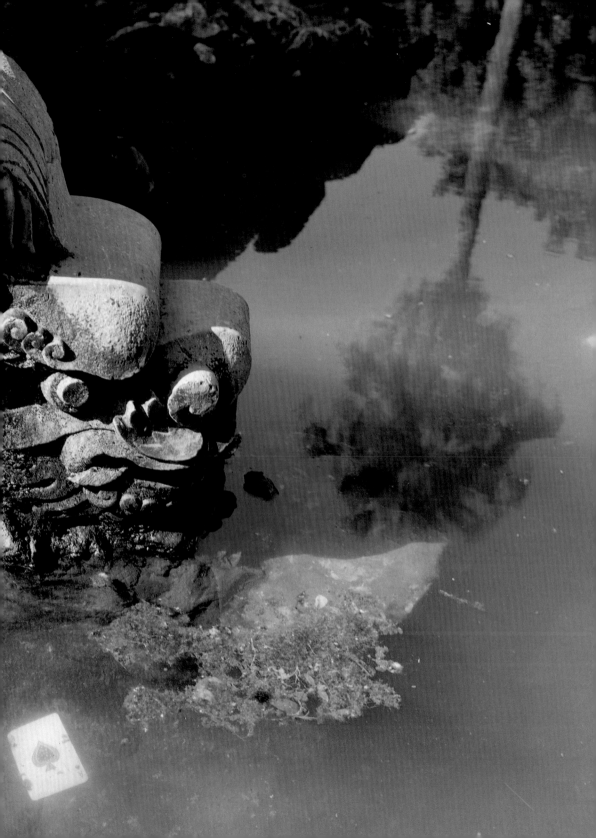

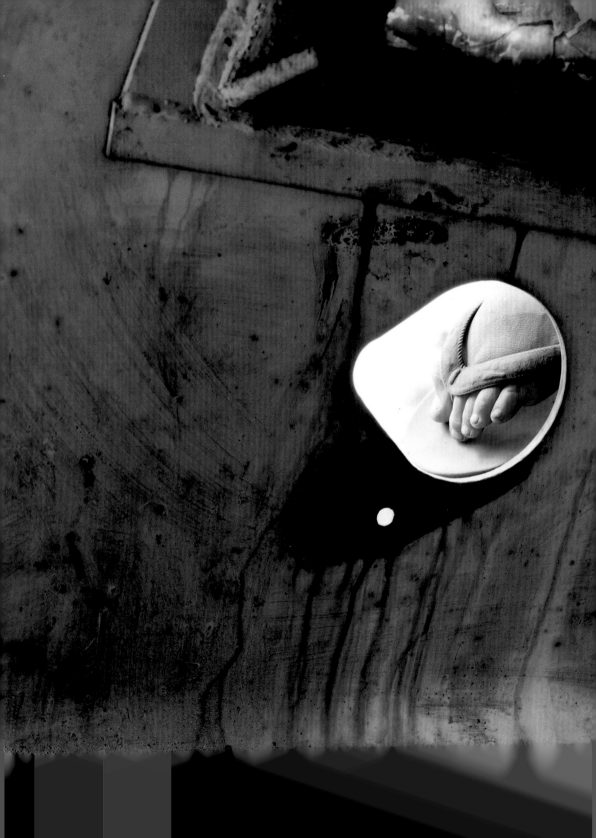

{ for Susan Bell }

Mitch Epstein VIETNAM A BOOK OF CHANGES

A DoubleTake Book
Published by the Center for Documentary Studies
in Association with

W.W. Norton & Company
New York · London

REFLECTIONS

. .

*T*HERE WAS SO MUCH I did not, and do not understand. In Vietnam,
and in Hanoi in particular, I felt comforted and unnerved. I was seduced
by the foreign beauty and mysterious rituals of the place. Hanoi was a
city shut off from the world for the last thirty years, and no doubt this time warp
contributed to its singular charm. But I could never sit pretty with this "charm."
For even as I felt enchanted, repugnant images assailed me; politics permeated the
air; and a convoluted protocol turned friendships into intricate maneuvers, where
understanding and trust could never be taken for granted.

On my first trip, I was very nervous. I landed at the Nội Bài Airport on an
April afternoon. I was nervous that my visa papers would be out of order,
nervous about the thousands of dollars in cash I was carrying, nervous simply to
be an American in Hanoi.

On the other side of the immigration booth stood Mr. Chung, the young
man chosen to be my guide, interpreter, and watchdog. Mr. Chung was a rookie in
the Foreign Press Service, an arm of the Ministry of Foreign Affairs of the
Socialist Republic of Vietnam. He was young and earnest—in some ways a little

like myself—but with allegiances very different from mine. He must have sensed my fear and dislocation, and was quick to establish his authority.

We were driven to the city in a new Japanese car, and for an instant I felt like a special state guest, until I realized how much extra I was paying for the privilege. First, to the Army Guest House, which was to have reserved a room for my stay but somehow didn't have my name on the register. I was then taken to the State Guest House, also fully booked. Finally, at the Tổng Đàn Guest House I was given the last available room, a suite with a black-and-white television, pink comforters, and red heart shaped pillows.

On this, my first trip to Vietnam, I was traveling on a journalist visa, which led the Vietnamese government to assign me Mr. Chung. For my five subsequent trips, I got a tourist or artist visa; with these, I was free to roam the country on my own.

Walking through Hanoi for the first time, I saw the street sweepers. Women pushed rusty wheelbins and tall brooms. They cleaned the street of garbage and had the Sisyphean job of gathering leaves that fell from towering trees. Hanoi has trees like no other city: ancient flame, teak, banyan, milkwood, and cassia. Their roots grow under the faded ocher Beaux Arts buildings left by the French colonials, and interfere with the new concrete boxes going up. One of my great pleasures was to lie back in the seat of my slow-moving cyclo, and lose myself in the view of the city's forest ceiling.

One morning during my first week, I couldn't sleep. At 5:00 a.m. I went out for tea in a shop that was still setting up tables. Rain began to come down in torrents. The calm of the tea shop proprietor was impressive. He sat cross-legged on the floor, in soiled blue pajamas, smoking a Vietnamese water pipe. He was economical with his movements and energy. As thunder and lightning struck nearby, he never flinched. Later, I glanced out the window of my room and noticed him in an alley pissing his morning tea.

Later that day, on my way to the old, medieval heart of the city, I walked into the smell of boiled cream and sugar. Young girls on Tràng Tiền Street,

dressed in white *áo dàis,* juggled ice cream sticks. They kept a second one in their spare hand to be eaten when the first was finished. The girls, the ice cream, the old-fashioned traffic lights above them, reminded me of a small Midwestern town on a saturday afternoon, circa 1945.

In the course of only three years, Hanoi's small town feel would be greatly transformed. It was on six long trips to Vietnam, from 1992 to 1995, that I made the pictures for this book. On each subsequent trip, I did not recognize Hanoi streets I'd been down before, because their old storefronts no longer existed. The beauty parlor where I photographed a woman under a red hair dryer was now a photocopy shop; the family restaurant I ate in was now a travel agency. The face of Hanoi was shifting at a miraculous rate as it opened its arms to the modern world.

W HEN I LEFT VIETNAM after my first trip I was relieved to go. The rough roads, the poverty, the kafkaesque communications with government officials had drained and depressed me. But a year later, and again and again, I felt pulled to return to Hanoi. It was and still is a pull I find hard to define. From my journals and letters it is clear that I was wedded to the intense, bittersweet world I encountered there:

"I've been thinking about greed, and often photographing people on the street counting money. And the color red. A roasted red pig. Red flags. Red Cinderella slippers, and the red color of chicken blood dripping into a rice bowl."

"The five kilometer climb up to the cave temples was long, hot, and difficult. Sweat and more sweat. I carried my tripod, remembering the cavernous chamber by the Buddhist temple, where a soft light filters down through fern trees and mixes with the smoke of ten thousand burning joss sticks. Again and again we pass pilgrims chanting *na mô a di đà phát.* I wore hiking boots and fell on the wet mountain footpath five times, while my sixty year old host, in plastic sandles, made the climb effortlessly.

"At the top, there was a picture to be made, of a young girl in a blue *mao* shirt, with three snails for sale, a wall of smoke hovering behind her. As we entered the cave and descended into the darkness, small candles flickered in the distance, and I recalled seeing the lights of a faraway city at thirty-three thousand feet from the window of an airplane."

"I went to a market in the old quarter to buy flowers for a friend's art opening (everyone brings bouquets to openings in Hanoi). I walked through the fish and meat lanes. I am repulsed and challenged by the endless displays of animal organs. My shooting feels more intimate and sometimes frightening. I am playing with the "still life"—to find a way to give it its own temperature. Moving in closer with the camera. The beauty-devil is no longer the problem."

"As I am packing to leave for New York, I hear the sound of drums. From my third floor balcony I see a funeral procession slowly pass. A long row of female monks, then the yellow schoolbus that carries the body, then two men, handkerchiefs over their mouths, walking backwards, their hands touching the bus.

"On top of a wood coffin ten red candles burn. The coffin sits at the rear of the bus which is open. A procession of mourners follows. Three women covered in white gauze grab at the coffin, walking and wailing, accompanied by a traditional string band."

"A few nights ago I was invited for tea at a friend's. On arriving, I found my friend and his family watching a videotape of his father's funeral. As they watched themselves wailing on the TV screen, they succumbed to hysterical laughter. Later they explained about the wailers for hire—old, poor folk who are paid to weep and moan at funerals."

I keep asking myself: what was it that drew me—what *exactly?* Other landscapes are beautiful, other worlds mysterious. The answer is the people. It was their blending of simple values and sophisticated thought; their generosity, depth, and energy; their ability to absorb outside influences—Chinese, French, Russian —without losing their own unique character; their resourcefulness and dignity in the face of repression and want. It was the many afternoons sitting in low chairs,

drinking strong amber tea from thimblelike cups my host would refill every few minutes. Taking tea with people formed the axis of my trips. Taking tea with painters, farmers, doctors, a blind guitarist, a filmmaker, a cyclo driver, a secretary, an herbalist, an astrologer, an architect, a monk; I was always taking tea with people, as conversations slowly stitched together, and I left regenerated, amazed at the range of lives I was able to meet, the different homes I was invited to enter. It was the Vietnamese themselves who drew me on as I pursued this project.

*T*WO WEEKS INTO MY STAY I took a road trip, north to south. Down Route 1, hardship followed hardship for the Vietnamese in these northern provinces. In Hà Tĩnh province, the land is barren and even the simplest crops are difficult to grow. The poor of the poorest live here, and women at night stand naked by the side of the road to lure truck drivers.

It took three grueling days on a narrow rutted road that is Vietnam's national highway, connecting Hanoi and Ho Chi Minh City, to arrive at Vĩnh Linh. Here the villagers once lived in an underground warren to avoid American bombers. We were just north of the seventeenth parallel. My interpreter and I made our obligatory visit to the local Communist Party Committee Headquarters, with offerings of American cigarettes and dollars.

Imagine the feeling of being three stories underground, in a tunnel with a ceiling height of four feet, minimal air, a faint flashlight, and matches, to be told not to get too close to the poisonous creature with twenty-four legs that clings to the ceiling above you. I could hardly cope with this single spider, while an entire village weathered life for years underground during the war.

When I first saw my tunnel pictures I couldn't look at them. Maybe the fear of being in those airless spaces was so suffocating that I chose to turn away from it, even from the relative safety of photographic representation. It took me two

years to acknowledge those pictures. It also took time to understand their connection to another kind of claustrophobia I had been feeling in Vietnam.

What was this feeling of entrapment that had begun to come over me? After all, I was an American and I could come and go, from America to Vietnam and back again. But the Vietnamese could not, and my empathy for them began to affect me. My friends in Hanoi were not free to move about the world as they pleased. The government would not grant most of them visas; even if it did, their sorry finances would not permit them to leave. I kept remembering the village children we met outside Điện Biên Phu who chased crickets and rats in the rice paddies to put protein into their diet—what could traveling possibly mean to them?

I began to understand Vietnam's contradictions better with the help of a friend. I had wanted to know Vietnamese culture as more than a foreign observer, so I had invited a Vietnamese novelist to collaborate with me. He'd agreed to write stories to accompany my photographs. His stories would draw from his own life, our many meetings in Hanoi, and the experience of living with my pictures of his country.

The writer, whose name I must protect, made me face the new era of Vietnam called *đổi mới.* Coined in 1987, *đổi mới,* similar to Russia's *perestroika,* is the Party term for economic and cultural renovation. It was, he pointed out, a concept full of contradiction; people were freer, but not altogether free. In this new, increasingly capitalist Vietnam, former enemies were now celebrated state guests. Yen, marks, francs, and dollars held new meaning to high-level cadres as well as to the coconut seller on the street. Yet here was a writer who was hardly free to write and publish as he wished. Our meetings were under surveillance and often canceled for inexplicable reasons. The giddy excitement I had come to witness on the street, as families turned their homes into new businesses overnight, was not an excitement my writer friend had the luxury to share.

For the first time I faced the threat of political intervention in my work. The threat became a backdrop to my days. I worried about being watched. My associations with dissident artists, I was told, might make me suspicious to the

Ministry of the Interior. Were my faxes read and phone calls bugged? I could never be sure. Never send faxes through the post office, friends said, as they pass through a central internal security office, are read, and may or may not be sent along.

I had set out to do a project that was artistic and cultural in scope. I had thought its political slant was simply historical and mine to control. But I had been ignoring the fragile freedom of my collaborator; I had, in essence, been ignoring that politics were an inextricable and active and uncontrollable part of my project.

In the two years my collaborator and I worked together, Vietnam's climate for freedom of expression worsened considerably. As I write this today, it is not possible for a Vietnamese writer to publish work abroad without the approval of the Ministry of Culture and without first being published in Vietnam. My writer friend had approval for most of his text when a new, unforeseen problem arose. The Vietnamese authorities, he said, would have to see my photographs and approve them. If I didn't submit my work to the Ministry of Culture for possible censorship, the writer feared repercussions for him and his family. It would not be possible, he said, to put the picture of the four Ho Chi Minh statues in the book. Government officials would find the photograph irreverent. No less than Buddha and Confucius, Ho Chi Minh is a Vietnamese god.

This picture had been made without a political agenda, but now it had one. I had passed a shop selling busts of Ho Chi Minh. I loved the way the shopkeeper had set them in a row, each one more unveiled than the last. Without altering them in any way, I made a couple of photographs. The picture of the busts became a symbol for other pictures. Other pictures that the authorities in Vietnam may or may not have liked; pictures that do not depict the happy idyll Communist officials favor; pictures of torn houses, a veteran begging, imported urinals, erroneous math equations on a villager's door, a close-up of a roasted dog's head.

What began with the Ho Chi Minh statues ended with the issue of censorship. In fact, the Association of Plastic Artists, a government agency that helped with my project, had only given me generous, open-minded guidance.

But despite my trust in the people running that Association, I believed that I must not participate in the Ministry of Culture's rule of censorship. I was unwilling, as an American artist, to submit my work to being censored, and so the collaboration died. Naively perhaps, I'd tried to cross one cultural bridge that has not yet been built.

I SPENT ONE MORNING photographing at Ga-Hànôi, the main train station. It is forbidden to walk onto the quai without a ticket. I had to bribe my way on for five dollars, the equivalent of a week's salary for the station attendant. Walking onto the quai was like entering a Czechoslovakian film in the fifties. What was not old sat beneath the soot from the black steam locomotives, and became old quickly. Melancholy pervaded the station. Goodbyes lingered, as the Parisian-green passenger cars of the train to Saigon screeched out of sight.

The blue wood door to the switching station had the serenity of a Rothko painting. To my back, an engineer bathed his feet with the hot water gushing from the steam valve of his locomotive. As lunch approached, the station emptied out, leaving a lone woman still waiting for a train to arrive, a bouquet of lillies tied to her bicycle handlebars.

The speed of Hanoi's changes never stopped amazing me. Decaying Beaux Arts buildings crumbled with the blow of a sledgehammer while the first McDonald's was rumored to open. The Hanoi Opera House is one Beaux Arts beauty that still stands, an imposing monument to the French era in Hanoi. I made repeated efforts to see its interior, and always found its gates locked with heavy chains. One November its elegant doors were open. Long banners hung from the balcony. Tickets were being sold for an all-Vietnam Youth Music Competition. I bought a fifty-cent ticket, and began to explore the opera's faded chambers to the muffled sound of Vietnamese teenagers playing Mozart and Bach in the main hall.

There was a reception room upstairs full of mirrors and windows. A long table was set up for a reception. The Vietnamese government would be receiving an American business delegation later that day. This colonial relic had found new purpose with the country's economic opening.

But the room refused to conceal its past. In several mirrors reflecting chandeliers were spidery bullet holes. I was told they dated to the 1954 fight against French occupation.

My curiosity took me to an upper stairwell that led to the roof. I was not supposed to be wandering around there unaccompanied, so I moved fast. I climbed some stairs and found blood red graffiti on the saffron colored walls and roof door. Months later, a friend seeing my photograph of it, translated: "In Vietnam, we must buy products made in Vietnam. This is evidence of the end of colonialism."

Days later, I sat at the Metropole Hotel eating a buffet breakfast, listening to two Indian businessmen speak in Hindi about Vietnam prospects. The Metropole was once the watering hole for war correspondents. It had been recently reopened, its decrepit interiors renovated by a French chain, creating Hanoi's only luxury hotel. Its lounge and dining room now were crowded with carpetbaggers. On weekdays you could find investors from Hong Kong, Taiwan, Singapore, Japan, Australia, France, Germany, and only recently America. I looked out the grated window by my table, my view obscured by heavy condensation. I made a picture of that moist curtain that divided the air-conditioned world within from the hot streets outside.

*A*S AN AMERICAN, I was treated only with respect. Other American visitors have noted with surprise how kind their former enemy is to them. One day I met a very educated Vietcong veteran. He had visited with American veteran groups in the United States, as an act of mutual reconciliation. How is it, I asked, that Vietnamese no longer harbor anger toward

their former enemy? "We are like hot coals," he said, "red beneath the cool white ash." But another Vietnamese, a documentary filmmaker, gave a different view. "We were taught," he said, "first through Buddhism, then Communism, the difference between power and people. You are American, but you are not the United States government. You did nothing to us, why should we resent you?"

On a trip to Bát Tràng, a pottery center outside of Hanoi, a master potter who had lost a leg to the war welcomed me to his studio. We had tea and made conversation as I admired his craft. As I was preparing to leave, he offered me a present, and told me there was special meaning in the vase he chose for me. It had a small chip at its mouth, and he said that chip represented the American embargo, and when it was lifted I could come exchange the vase for a perfect one.

I remember him when I think about *Vietnamerica* and its offshoots. *Vietnamerica* was a trade fair held in Hanoi and Saigon in 1994 to reintroduce American business into Vietnam. Thousands waited in line for free entry to a big white tent. Inside they scrambled for free Colgate toothpaste samples, and scrutinized other American specialities: Kraft marshmallows and jelly; a toilet bowl deodorant from a small company in Alabama; and Marlboros, promoted by sexy Saigon girls in suede skirts and cowboy boots who were giving away cigarettes. What Disneyesque nightmare will come from all this? Will Vietnam end this desperate era of international isolation, only to reshape itself according to Western industrial ideals, Western cultural trends??

*M*Y SLEEP WAS JARRED by a loud bang on the wooden door. "Mr. Mitch!, Mr. Mitch!," my driver yelled. "There is something you would like to see." Mr. Mai had come to know what might visually excite me, almost always something the Vietnamese found too ordinary or too grotesque to photograph. We were in Sapa, a hill station northwest of Hanoi. The mountain air chilled me as I climbed through a pink mosquito net.

At 5:00 a.m., a carpet of termites covered the terrace I had to cross to join Mr. Mai below. He shouted to come quick. A just slaughtered cow lay in the middle of the village road. Two women, in red lipstick, fancy shirts, and high heels, proceeded to carve its parts as dogs licked the rivers of blood that trickled out. With a minimum of dawn light, feeling nauseated by the smell of blood and freshly exposed organs, I made frame after frame of this primal event.

A week later, it was the full moon, the day Vietnamese Buddhists pray at their pagodas, and I went to Quán Sử, a pagoda resurrected by a group of elder women. I got lost in making still-lifes of offerings: roses and lychees, sweet biscuits and play-money, all in clouds of incense smoke.

Vietnam was all of this: slaughter and lipstick, roses and incense, tea and patience, business delegations and new money.

I AM NOT A VETERAN, but I am an American. This project began with the memory of a war I had not fought and yet, by definition as an American, had suffered. I wanted to feel and understand that war as much as a non-vet can. It was inevitable then that I flew to Hue, not to see its imperial tombs but to hire a car and driver to Khe Sanh.

At Đông Hà, the capital of Quảng Trị province, we stopped at the local DMZ tour office, where fees had to be paid and a guide contracted. Their ungrammatical motto: "We are the only know about DMZ." The local cadres had found a lucrative business in returning American veterans and other tourists who wished to visit the former site of the most brutal battles of the war.

The trip began to feel more and more uncomfortable, and it brought my first travels to mind. I wanted to be alone. I didn't want a guide as I made my pilgrimmage to these hellish sites. I didn't want to hear every statistic.

At Trường Sơn National Cemetery, a group of schoolchildren had come to offer prayers to their war heroes. As I listened to the ceremony on portable loudspeakers, I noticed a patch of cactii covered with Vietnamese graffiti. There

were mostly Vietnamese names and dates, but one, written in English, read "Don't Forget Me."

By midday we reached Khe Sanh, only twenty kilometers from the Laos border. Nestled in the lush mountainside, Khe Sanh was one of the most horrific outposts of the war. Its access had been by air only. American generals dropped in a prefab air strip and base, which became an undefendable defense line. Where the airstrip once lay, we were greeted by a pack of kids, all competing to sell me, the only foreign visitor, souvenirs of lost American medals and odd trinkets, including the burned letter "E" from a scrabble set.

The contrast between the red clay land and the verdant hillsides was startling. Strong winds blew hot dust from the scavengers' holes, which dotted the plateau. This is what there was to see here: still lifes of found grenades and American military boots and remnants of abandoned rations. The steel plates that were the runway had been pulled up years ago and placed upright as walls for local houses, or sold as scrap to Japanese buyers who shipped them to Japan and back again to Vietnam, as cars for the top brass.

On the drive back, I stopped to look at a house with walls built from the runway. I was welcomed inside and offered tea (of course) and then lacquer wine. One of the sons had just been bitten by a snake. He was wearing its head on his bitten finger, a local antidote to the poison. The whole family laughed hard when I photographed the snake ring.

I had seen enough, bought the scrabble "E," and walked back to the car with ten kids in tow. All I had to share with them was a cooler full of Coke and beer. I handed cans around. This was the first Coke and the first beer some of them had ever tasted. Inspired by the sugar and alcohol and novelty of it all, they made up a song about sugar cane, and sang the simple verse over and over again: "Some cane blessed with sweetness, some cane blessed with bitterness, some cane blessed with bitterness, some cane blessed with sweetness."

New York, February 1996

I

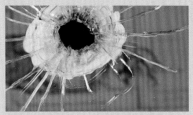

{1} Hanoi Opera House 1993 (*bullet hole circa 1954*)

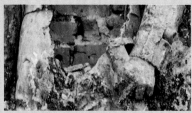

{2} Phát Diêm Cathedral 1994

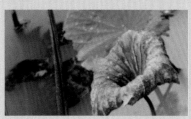

{3} Lotus Pond, Ha Sởn Bình Province 1993

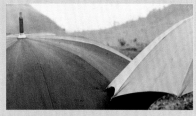

{4} Rice Farmers' Lunch, Lai Châu Province 1995

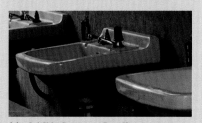

{5} Lai Châu Government Guest House 1995

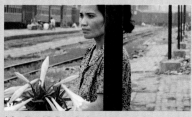

{6} Hanoi Railway Station 1992

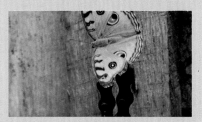

{7} Butterfly on Bicycle Chain, Hue 1992

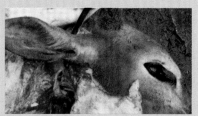

{8} Butcher at Dawn, Sapa 1995

{9} Elder with Water Pipe, Hanoi 1995

{10} At the Foot of the Buddha, Nha Trang 1992

{11} Billboard and Communist Mural, Hanoi 1995

{12} Buying Sour Plums, Hanoi 1995

{13} Mường Village, Lai Châu Province 1995

{14} Saigon Bakery 1993

{15} Pillow of Honey Lady, Hanoi 1995

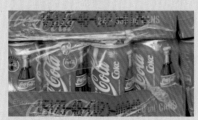

{16} Coca Cola Truck, Hanoi 1995

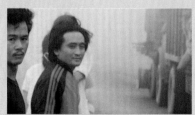

{17} "Pass of the Ocean Clouds," Highway One 1992

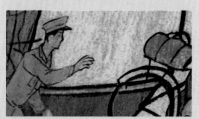

{18} Mekong River Ferry Sign 1992

{19} American Tank Exterior, Hue 1995

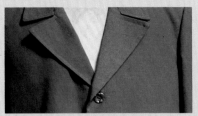
{20} Tailor Shop, Hanoi 1995

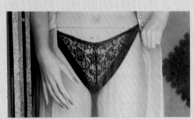
{21} Former Presidential Palace Kitchen, HCM City 1994

{22} Hair Wash, Hanoi 1994

{23} "State General Department Store," Hanoi 1995

{24} Karaoke Room, Sơn La 1995

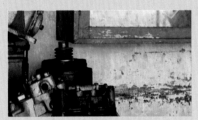
{25} Machine and Barber Shop, Nha Trang 1992

{26} Playing Cards in a Chicken Market, Hanoi 1994

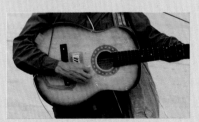
{27} Itinerant Beggar, Điên Biên Phu' 1995

{28} Photo Studio, Hanoi 1995

II

{29} Soap Opera, Hanoi 1995

{30} Mirror Shop, Hanoi 1995

{31} Opera House Balcony, Hanoi 1994

{32} Dog's Head, Market 19, Hanoi 1995

{33} Ecole Des Beaux Arts, Hanoi 1995

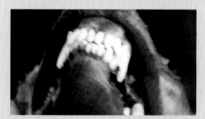

{34} American Boots and Artillery Shells, Khe Sanh 1995

{35} Cha' Cá Restaurant, Hanoi 1993

{36} Former Presidential Palace Basement, HCM City 1994

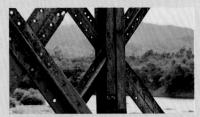

{37} Railroad Bridge, Quảng Trị 1995

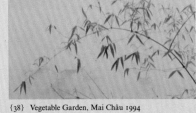

{38} Vegetable Garden, Mai Châu 1994

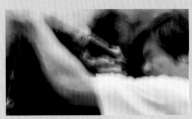

{39} Perfume Pagoda, Ha Sơn Bình Province 1993

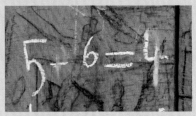

{40} Imperial Gardens, Citadel, Hue 1992

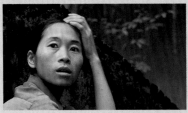

{41} Homemade Rifle Demonstration, Lai Châu 1995

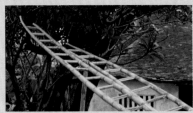

{42} Village House Exterior, Sơn La Province 1995

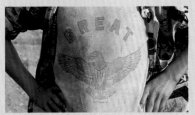

{43} American Eagle T-shirt, Sơn La Province 1995

{44} Rental Wedding Dresses, Quảng Trị Province 1995

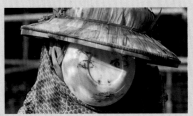

{45} Scarecrow, Mai Châu 1994

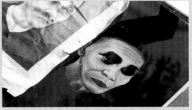

{46} Tombstone Engraving, Hanoi 1994

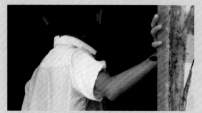

{47} Temple Mural, Châu Đốc 1992

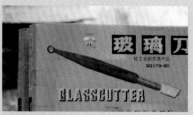

{48} Glasscutter, Hanoi 1994

{49} Trường Sòn National Cemetery 1995

{50} Beauty Salon, Hanoi 1993

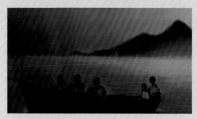

{51} Hotel Dining Room, Hàiphòng 1993

{52} Metropole Hotel, Hanoi 1994

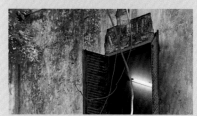

{53} Fluorescent Light, Hanoi 1993

{54} Hotel at the Seventeenth Parallel 1992

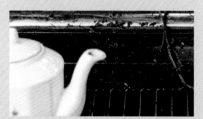

{55} Arts' Association Parking Lot, Hanoi 1994

{56} Photographer's Shop, Hanoi 1994

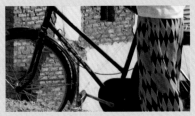

{57} Torn Houses by the Dike, Hanoi 1995

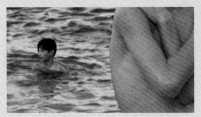

{58} Student Monk, Nha Trang 1992

III

{59} Fresh Water Buffalo, Hòa Bình Province 1994

{60} French Windows, Hanoi 1994

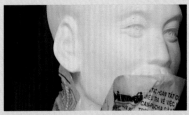

{61} Ho Chi Minh Statues, Hanoi 1994

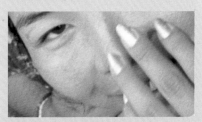

{62} Street Vendors, Ho Chi Minh City 1994

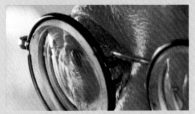

{63} Duong Tường, Road Trip 1995

{64} Voltage Regulator and Pig's Foot, Hanoi 1995

{65} Mai and Trinh Tường, Hanoi 1993

{66} House Saint, Ho Chi Minh City 1994

{67} Construction Workers' Tea, Hanoi 1993

{68} Chipped Graffiti, Hanoi 1995

{69} Mud Bath, Mai Châu 1994

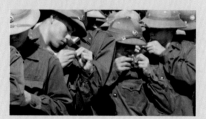

{70} Military Ceremony, Sơn La 1995

{71} Opera House Reception Room, Hanoi 1995

{72} Metropole Hotel Men's Room, Hanoi 1995

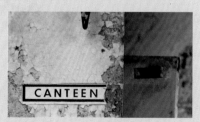

{73} American Tank Interior, Hue 1994

{74} Stations of the Cross, Phát Diêm 1994

{75} Tổng Đàn Guest House, Hanoi 1994

{76} Tunnel Air Shaft, Vĩnh Mộc 1992

{77} Flame Trees, Hanoi 1995

{78} "In Vietnam Buy Vietnamese," Opera House 1993

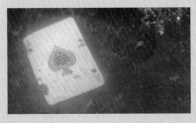

{79} French Fountain and Ace of Spades, Hanoi 1994

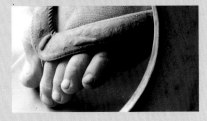

{80} U.S. Tank Interior and Vietnamese Boy, Hue 1994

ACKNOWLEDGMENTS

*T*HIS WAS A PROJECT *that I could not have seen through on my own. Very special thanks to Madame Vũ Giang Hương and Lê Phương Lan at the Association of Plastic Arts in Hanoi, as well as to my friends Mai, Lương, Tưởng, and their families for their hospitality and generous help during my time in Vietnam.*

My profound thanks to Christoph Gielen, a master color printer, for his sublime prints, keen judgement, and dedication at every stage of this book's production.

I am grateful to Nina McPherson and Phan Huy Đường for their fine translations and indispensable guidance; to Eliot Weinberger, for his superb ideas—many were essential to this book; to Anthony McCall, for the intelligence of his eye and his collaborative spirit; to Mikio Shinagawa, for his early commitment to my Vietnam work, and for inviting me to Tenri, Japan: the commission I did there helped make my trips to Vietnam feasible.

Thanks to the following, who went out of their way to help me with this project: Anthony Accardi, Celeste Bartos, Nguyen Nguyet Cam, Tim Carr, Kathy Charlton, George Evans, Wendy Ewald, Eli Gottlieb, David Jacobson, Evan Ham, An Mỹ Lê, Marcia Lippman, Phương Anh Nguyen, David Schwab, David and Jean Thomas, Mark Wanger, Cora Weiss, and Peter Zinoman. Thanks to Linh Dinh for his notable translations and valuable advice.

I am grateful to my editors Jim Mairs at Norton and Iris Tillman Hill at DoubleTake, who had the courage and imagination to produce this book in ways that went against convention; to Alex Harris and Robert Coles at DoubleTake magazine and the Center for Documentary Studies for publishing the Vietnam pictures first; and to the IndoChina Arts Project for lending a knowledgable hand from the beginning. I am especially grateful to the Pinewood Foundation for critical financial support.

Heartfelt thanks to my parents, Ruth and Bill Epstein, for their unwavering faith.

Most importantly, I thank Susan Bell, my wife. She has given immeasurably to this work. Her passionate and crucial engagement with my pictures continually fueled their growth. Her linguistic talents helped guide my collaboration in Hanoi. And, as the incisive editor of my text, she inspired the confidence in me to write.

VIETNAM: A BOOK OF CHANGES
by Mitch Epstein

Copyright © 1997 by BLACK RIVER PRODUCTIONS LTD.
Library of Congress Cataloging-in-Publication Data
Epstein, Mitch, 1952–
Vietnam: a book of changes / Mitch Epstein
p. cm.
"A DoubleTake book."

1. Vietnam–Pictorial works. 1. Title.
DS557.72.E67 1996
959.7–dc20 96–22871
ISBN 0–393–0427–5

Manufacturing by Arnoldo Mondadori Editore, Verona, Italy
Book design by Anthony McCall Associates, New York
Cover photographs by Mitch Epstein
Printed in Italy

W.W. NORTON & COMPANY, INC.
500 Fifth Avenue, New York, NY 10110
http://www.wwnorton.com

W.W. NORTON & COMPANY LTD.
10 Coptic Street, London WC1A 1PU

1 2 3 4 5 6 7 8 9 0